SOCIAL AND POLITICAL CHANGE
IN LITERATURE AND FILM

SOCIAL AND POLITICAL CHANGE IN LITERATURE AND FILM

Selected Papers from the Sixteenth Annual
Florida State University
Conference on Literature and Film

Edited by
Richard Chapple

UNIVERSITY PRESS OF FLORIDA
GAINESVILLE

Library of Congress Cataloging-in-Publication Data

Florida State University Conference on Literature and Film (16th : 1991)
 Social and political change in literature and film : selected papers from the
Sixteenth Annual Florida State University Conference on Literature and Film
/ edited by Richard Chapple.
 p. cm.
 Includes index.
 ISBN 0-8130-1286-4
 1. Literature and society—Congresses. 2. Social change in literature—
Congresses. 3. Politics in literature—Congresses. 4. Motion pictures—
Political aspects—Congresses. 5. Politics in motion pictures—
Congresses. I. Chapple, Richard L., 1944- . II. Title.
PN51.F54 1991
791.43′658—dc20 93-35010
 CIP

The University Press of Florida is the scholarly publishing agency for the State
University System of Florida, comprised of Florida A & M University, Florida
Atlantic University, Florida International University, Florida State University,
University of Central Florida, University of Florida, University of North Florida,
University of South Florida, and University of West Florida.

University Press of Florida
15 Northwest 15th Street
Gainesville, FL 32611

CONTENTS

1 INTRODUCTION
Richard Chapple, *Florida State University 1*

2 WIM WENDERS'S EURO-AMERICAN CONSTRUCTION SITE:
PARIS, TEXAS OR TEXAS, PARIS
Duco van Oostrum, *University of Groningen 7*

3 DOUBLE VISION: SCORSESE AND HITCHCOCK
Barbara Odabashian, *The City University of New York 21*

4 TRANSFORMATIONS OF TERROR: READING CHANGES IN SOCIAL
ATTITUDES THROUGH FILM AND TELEVISION ADAPTATIONS
OF STEVENSON'S *DR. JEKYLL AND MR. HYDE*
Brian Rose, *The Ohio State University 37*

5 DECENTERING THE SUBJECT: DAVID HARE'S *WETHERBY*
Nicholas O. Pagan, *Auburn University 53*

6 REPERCUSSIONS OF THE CIVIL WAR IN THE CANARY ISLANDS
Margarita M. Lezcano, *Eckerd College 65*

7 CINEMA WITH A FUTURE:
THE DEVELOPMENT OF FILM IN QUEBEC AS AN
AUTHENTIC EXPRESSION OF QUÉBECOIS CULTURE
Philip Reines, *SUNY-Plattsburgh 73*

8 THE CRACK IN THE FAÇADE:
SOCIAL AFTERSHOCKS OF MEXICO'S 1985 EARTHQUAKE
Mary Tyler, *Tallahassee, Florida 83*

9 FICTION INTO FILM:
"IS DYING HARD, DADDY?" HEMINGWAY'S "INDIAN CAMP"
H. R. Stoneback, *SUNY-New Paltz 93*

10 REAR WINDOW'S LISA FREEMONT:
MASOCHISTIC FEMALE SPECTATOR OR POST-WAR SOCIOECONOMIC THREAT?
Carol Mason, *University of Minnesota 109*

11 REVOLUTION AS THEME IN JOHN OLIVER KILLENS'S *YOUNGBLOOD*
Charles Wilson, Jr., *Old Dominion University 123*

INDEX *133*

1. INTRODUCTION

Richard Chapple

ALL OF THE MAJOR CHANGES in the world haven't occurred in the
last few years. It just seems that way. "Who would have thought?"
questions have been commonplace in recent years. The eyes of at least
the Western world have been focused on Berlin, Poland, Kuwait,
Czechoslovakia, Moscow, the former Soviet republics, Albania,
Tiananmen Square, Yugoslavia, Romania, the Middle East peace talks,
etc. The focus upon these upheavals has provided respite from the
familiar stresses of the world as we knew it, as well as a perspective on
how things could be. Even the politics of a presidential election year
have become tinged with something more than the customary rhetoric
of change.

It seemed only right to hold a conference on social and political
change as it is reflected in literature and film. The fact that most of the
scholarly presentations had nothing to do with current dramatic political
events and socio-political upheavals says something about the nature of
change. Perhaps the literary and film response to these events is yet to
come. Perhaps social and political change is such a part of life's fabric
that the recent extraordinary changes partially serve to reinforce the
constancy of change. Perhaps other issues and events lend themselves

to scholarly and artistic attention in as significant a way as events of the recent past.

The fact and nature of change have long been contemplated. That change exists is hardly to be denied, but defining specifically what it is has seemed to be a matter for the philosophers, while evaluating the impact of change is the province of us all. It is this broad category of evaluation that concerns this volume. Time and history allow us to mark progress and evolution, which in turn leads us to make evaluative judgments. The plenary session lecturers at the conference dealt with ideas as disparate as the evolution of women's fiction in the former Soviet Union and the changing sexual representation of the male body. While those ideas may not be as compelling as Tiananmen Square, they nonetheless illustrate the world in which we live.

The fact that the scholars attempt to deal with both the artistic representation of change as well as the nature of the artistic representation provides added perspective. Thus, we can read in this volume of the artistic repercussions produced by a political event, such as the civil war in the Canary Islands; the evolution and representation of a displaced culture, such as Quebec; the evolving consciousness of a minority, such as the female spectator; and the impact of change on popular culture, such as Americana as seen in adaptations of *Dr. Jekyll and Mr. Hyde.*

H. R. Stoneback examines Brian Edgar's film of Hemingway's acknowledged masterpiece "Indian Camp." A recognized expert on Hemingway, Stoneback served as a consultant for the film and experienced firsthand the uneasy truce between the writer, the literary text, the director, and the film. The issues that arise are stridently modern and include the perception of Native Americans amidst the politics engendered by the 1960s and their aftermath, as well as the film's "Indianization" of the tale. Stoneback concludes that it was possible to produce a good film, despite leaving out much of Hemingway, and that merging the literary and film sensibilities is no easy task.

Brian Rose scrutinizes the much-adapted narrative of Stevenson's *The Strange Case of Dr. Jekyll and Mr. Hyde* and identifies changes in American culture from the 1920s through the l990s. He focuses on the variability of myth rather than terror or suspense and shows that most of the myth and innuendo of the productions stem from the adapters rather than from Stevenson himself, who was less concerned than his adapters have been about economics, social class, gender, sex, and race. It is thus instructive that meaning is portrayed through interpretations of society's concerns at the given moment rather than through the prism of the author. It is also instructive to note that in recent versions evil endures and is not destroyed, which is reflective of our modern perception of things.

European perceptions of both America and Europe and their evolution through a complicated love\hate relationship are exposed by Duco van Oostrum as he reviews Wim Wenders's *Paris, Texas*. European ambiguity is seen in the tension between Paris, Texas, and Texas, Paris, and one can only wonder what Paris, Kentucky, would add to the equation.

Philip Reines looks at what may become a significant and exciting area of film in the future—film in Quebec as it attempts to be a voice for québecois culture. The genre is comparatively young, but since the 1960s it has chronicled the ethnic identity of Quebec and its struggle for political, ideological, and economic self-determination. Reines traces the development of Quebec cinema against the background of Canadian film as a whole in its struggles with the Goliath of Hollywood, and shows how the new tradition is attempting to convey ethnic flavor while maintaining the universal and the humanistic.

The role of the filmmaker and his view of life and society are examined by Barbara Odabashían, who views Martin Scorsese's *Taxi Driver* (1976) as a double of Alfred Hitchcock's *Vertigo* (1958). A detailed examination of the film credits reveals the doubling as well as the subtlety of both directors.

Nicholas Pagan takes a postmodernist view of David Hare's *Wetherby* and shows how the disjuncture of story and narrative serves to decenter the character and expose the subtext. The British national character, identified as finding it hard to talk about things, is taken to task, and the carefully hidden sociopolitical issues are thereby revealed. The net result is that social and political changes are not so imminent as they need to be.

A minor literary tradition that is poorly known in the West is described by Margarita Lezcano, who looks at Spain's Franco phenomenon and its impact in the Canary Islands. She uses Luis León Barreto's *The Infinite War* as a window to look upon post-Franco society and the changing social conditions. Barreto's treatment of the subject is rather typical of that written about the aggressors by those imprisoned, but the problem of rewriting history is nonetheless a challenging and fascinating one, especially as we are able to observe struggles with it in Eastern Europe and the former Soviet Union.

Mary Tyler looks at the work of essayists Carlos Monsiváis and Elena Poniatowska and their role in Mexico's popular genre of testimonial narrative, a combination of journalism and literature. The aggressive tone of the work exposes governmental corruption and ineptitude amidst the human tragedy of the 1985 earthquake, and Tyler sees an unfortunate national process of democratization by disaster.

The perspective of feminist psychoanalytic film theory is both utilized and taken to task by Carol Mason as she examines *Rear Window*. The author is able to show that the main character is not only an object of male voyeurism as required by the theory but is just as well an example of the post WWII socioeconomic stress between men and women. The fact that the film is susceptible to both readings illustrates the complexity of both art and theory.

Charles Wilson uses John Oliver Killens' *Youngblood* to examine revolution in the Jim Crow South. He exposes the tension between revolution and evolution and notes that the evolutionary cycle must be punctuated with strong revolutionary stands, despite the fact that radical

revolution generally fails. He also notes the poignant realization that life in the Jim Crow South is full of inconsistencies and that the desire for more obvious rights and wrongs is often frustrated. Wilson concludes that *Youngblood* is to a degree a common sense manifesto in the face of ongoing racial strife.

Social and political change as seen on the front pages and in the evening news shapes our perceptions of reality and ultimately of ourselves. Passed through the medium of art, however, such changes potentially assume a more profound significance. Reality and the self are enhanced and clarified, and that provides the justification for volumes such as this.

2. WIM WENDER'S EURO-AMERICAN CONSTRUCTION SITE: *PARIS, TEXAS* OR TEXAS, PARIS

Duco van Oostrum

WHEN I FIRST SAW *Paris, Texas* in the Netherlands, where it was highly praised as winner of the Golden Palm for best film at the 1984 Cannes Film festival, I asked the same question Walt Henderson did in the movie: "There's really a place called Paris, Texas?" By juxtaposing the worlds of Paris and Texas, the German film director Wim Wenders calls attention to the peculiar location of the place Paris, Texas as well as to the ambivalent position of his motion picture *Paris, Texas*. As a German/French co-production, the film enacts a European collaboration project to frame one of the supposedly most "primitive," most distinctly American areas of the United States: Texas. As such, the movie portrays a fairly typical European stereotype of America. *Paris, Texas* fits in a tradition of European watchers of America; yet, as I will argue, the movie looks beyond a limited European perspective.

Nevertheless, I was struck by the similarity of the spotlight on America in *Paris, Texas* and in Jean Baudrillard's study *America* (1986). Baudrillard is one of the most recent of European America

watchers, and, like his compatriot Alexis de Tocqueville a century-and-a-half before him, Baudrillard notes differences with European culture, especially focusing on the results of the "tyranny of the majority" (de Tocqueville's phrase) and the lack of tradition so particular to the vast American experience. As de Tocqueville warned Europe in 1835:

> The majority in the country [America], therefore, exercise a prodigious actual authority, and a power of opinion which is nearly as great; no obstacles exist which can impede or even retard its progress, so as to make it heed the complaints of those whom it crushes upon its path. This state of things is harmful in itself and dangerous for the future.[1]

Under the influence of the majority's "power of opinion," America appears to become, however paradoxical for a country which claims individual freedom for all its citizens, a world of conformity. De Tocqueville relates his experience with the relative uniformity of American people as follows: "It seems, at first sight, as if all the minds of the Americans were formed upon one model, so accurately do they correspond in their matter of judging" (53 Vol. 2). Especially in terms of taste and culture, the majority's power turned America into a cultural desert, according to European intellectuals. Even in a recent European course book on American culture by the Briton Peter Bromhead, America is still labelled a "cultural desert."[2] The metaphor implies sameness, lack of roots, immediate destruction of productive growth, and an immense endless landscape. For Baudrillard, as a modern theorist, America now has become illustrative of the condition of a postmodern world. America's rootlessness and its emphasis on appearances demonstrate the emptiness of the sign, in which a true referent does not exist. All that exists is an outside that covers an essential empty inside.

To illustrate how *Paris, Texas* shares this European focus on America, I will first view the movie from this angle, comparing scenes from it with Baudrillard's characteristic European pronouncements of America. Unlike Baudrillard, however, Wim Wenders adds to this stereotypical oceanic divide between Europe and America. In spite of

the chronological impossibility, it's almost as if Wenders has tried to render his America as European as possible (as if he were shooting the movie while reading Baudrillard's "script"), with the result that the viewer starts to notice the angle from which *Paris, Texas* is filmed. At least novelist Larry McMurtry also turns his attention to the title with a comic as well as telling analysis of Wim Wenders's movie. In *Texasville* (1987), McMurtry fictionalizes his native perception of Texas; while they are preparing to stage the history of "Texasville," the protagonists Duane and Jacy decide to watch the movie *Paris, Texas* on video. Already early on, Duane dozes off, and when it is (finally) over, Jacy sums up the movie: "They should have called it 'Houston, Germany.'"[3] Initially as a subplot to the complex and horrific family story of Travis Henderson, the place Paris, Texas assumes a plot of its own. By accentuating the film's own foreign glance at America, a viewer may receive a new look at the many dichotomized perspectives in *Paris, Texas.* The foreignness of Wenders's Texas produces a *Verfremdungseffect* which emphasizes the position of the camera on Texas from the point of view of that synecdoche of Europe: Paris—a Texas, Paris. At the same time, the play with Paris, Texas or Texas, Paris makes it uncertain whether there is any original view from a Europe or an America. Besides focusing on the typical European images of America, this paper will also examine the self-reflexive portrait of the movie's ambiguous place as an attempt to break the binary frames of both European and American perspectives.

The opening shot firmly places the movie in an America of familiar images. In the unvegetated hills and desert of Devil's Graveyard, Big Bend, Texas, Travis Henderson walks alone like the lonely cowboy of so many Westerns. Away from cultured society under the watchful eyes of a hawk, a solitary man faces the unfriendly forces of nature in order to find his identity. At once performing an Emersonian image of the individual in nature and an American image of "pastlessness," Travis wanders in the desert. That the scene appears in a screenplay written by American dramatist Sam Shepard should hardly be surprising. Shepard thrives on images of a mythic frontier America of lonely cowboys.

9

Lynda Hart, for example, sees Travis Henderson as "the recognizable quintessential Shepardian hero."[4] But in Europe this mythic frontier America as portrayed by Americans points not only to an opportunistic innocence, but also to a barrenness of American culture itself. When asked about Shepard's contribution to his film, Wenders praises him for the typical American identity he brought to the movie: "That's what Sam brought to this movie of mine as an American writer: forward movement, which is very American in a way. I've always liked that movement and have always found myself incapable of doing it."[5] While Travis wanders through the desert, Wenders seems to say, Shepard provides the forward motion and Wenders the direction for the American frontier hero who seeks refuge from society.

From a European perspective, the solitary hero who finds his (it is almost always "his") identity in an untouched nature becomes symptomatic of a dehumanized culture. In Travis's wanderings, the desert itself touches, at least in the paradigm of Jean Baudrillard, the heart of American culture. The process of "desertification," as Baudrillard calls it, indicates the extent to which the social world has become like an empty, sterile desert. Rather than a contrast to the city, the desert mirrors city life. As Baudrillard suggests:

> American culture is heir to the deserts, but the deserts here are not part of a Nature defined by contrast with the town. Rather they denote the emptiness, the radical nudity that is the background to every human institution. At the same time, they designate human institutions as a metaphor of that emptiness and the work of man as the continuity of the desert, culture as a mirage and as the perpetuity of the simulacrum.[6]

For Baudrillard, the desert comes to reflect the essence of American culture, at once the "most primitive society" (10) and the most modern society in the Western world. Regardless of the truth value of Baudrillard's assessment of American culture, the desert does take on the sign of a barren meaningless world in *Paris, Texas* in which Travis

tries to find a place. Neighboring on Travis's desert, his brother Walt and wife Ann live in a Los Angeles suburb. Walt constructs billboard sign advertisements as a profession, and his bourgeois life seems thus literally built on the empty signs of a Baudrillardian consumer culture.

The long scenes of driving through the US, moreover, show another particularly American aspect of life. Again in the words of Baudrillard: "Driving is a spectacular form of amnesia. Everything is to be discovered, everything to be obliterated" (9). The long drives in *Paris, Texas*—first from Big Bend to LA and second from LA to Houston—closely interconnect with Travis's restoration of his memory and of his effort to patch up some previous family life. On the first drive, Travis realizes why he wants to find Paris, Texas, and on the second drive he tries to find his wife Jane. The discovery of Travis's personal identity during these drives is coterminous with a discovery of a monotonous America. During these two trips, the vast driving distances visualize the enormous size of America, while at the same time the surroundings illustrate the relative uniformity of life in the US. The motels, the billboard signs, the empty spaces, the small towns, and even the big cities LA and Houston appear to border on the same endless road. Apparently, the images confirm the metaphor of America as a cultural desert. The discovery connected to driving in the movie obliterates the difference between places; America is the same everywhere.

Finally, the impressions of the big cities, LA and Houston, again repeat customary European images of American cities. When Travis surveys Los Angeles at night and in the early morning hours, he watches the continually moving planes and cars amidst an intricate network of "astral" freeways, in a city that never seems to sleep. Los Angeles by night, in the words of Baudrillard, is an inferno:

> The irregular, scattered flickering of European cities does not produce the same parallel lines, the same vanishing points, the same aerial perspectives either. They are medieval cities. This one condenses by night the entire future geometry of the networks of human relations, gleaming in

their abstraction, luminous in their extension, astral in their reproduction to infinity. (52)

Travis's fascination with the lights of LA and its network of freeways and runways may well metaphorically represent a disconnected "network of human relations." But even the portrayal of this luminous city from the high astral perspective of the suburbs confirms another European perspective, as one can read in Baudrillard's account of it. Besides a similar enchantment with freeway structures, the arrival scene in Houston focuses in on the massive, modern skyscrapers of downtown Houston. When the Europeanized Henry James visited America after a twenty-year absence in 1904, he was stunned by the "multitudinous sky-scrapers standing up to the view, from the water, like extravagant pins in a cushion already overplanted, and stuck in as in the dark, anywhere and anyhow." The skyscrapers represented to James one of the strikingly new and "terrible things in America," "the last word of economic ingenuity."[7] For Baudrillard, eighty years later, the American skyscraper still represents something distinctly American, the all-pervasiveness of surface structure:

> All around, the tinted glass facades of the buildings are like faces: frosted surfaces. It is as though there were no one inside the buildings, as if there were no one behind the faces. And there *really* is no one. This is what the ideal city is like. (60)

In *Paris, Texas* the skyline demarcates the desertification of a modern American city. Glass structures with hardly human life inside seem imposed upon the landscape. The bank at which Jane deposits money for Hunter every month turns out to be the pinnacle of "desertified" dehumanized relationships, an immense drive-through. When Travis watches the reunion of Hunter and Jane in the Meridian hotel, he merely gazes at the tinted glass facade of the skyscraper. The final shot of the movie shows Travis driving away alone from the desert of Houston in search of another place.

Even though *Paris, Texas* thus appears to affirm Europe's designation of America as a cultural desert, the movie furnishes this European portrait with images which make such an easy classification of cultures and perspective far more difficult and interesting. Is the place where Travis will seek refuge Paris, Texas? Besides the title of the movie, the phrase Paris, Texas appears at crucial junctions in the movie to denote the ambiguity and instability of its place. Each of the four times Travis mentions Paris, it signals a different stage in the story of his own metaphorical rebirth. The first time occurs when Walt has rescued Travis from his unconscious wanderings through the desert. After several days of silence, Travis's first words to Walt are "Paris...Paris...Paris." And when Travis asks Walt: "Could we go there now?" Walt responds with an apparently logical "It's a little out of the way. I've never been to Europe. Ann [Walt's wife] wants to go. Well, she's from there, you remember." Walt's inference that Travis means Paris, France, replays the joke Walt and Travis's father used to introduce his wife, the viewers later learn. At this stage, Travis does not correct Walt's misunderstanding and only smiles in the back of the car. The second time Travis introduces the subject of Paris, he does so through a picture he carries with him. When Walt asks to see that photograph of Paris, he is shown a photo of a vacant lot. "This is it, this is Paris?" Walt asks Travis, "This looks just like Texas to me." "It is, Paris, Texas," Travis answers. While Travis points to the map he tells Walt "It's right here on the map." Finally, Walt exclaims: "There's really a place called Paris, Texas?"

The dialogue between the brothers foregrounds the doubleness of place. The confusion between Paris, France and Paris, Texas that occurs between the brothers is replayed on several levels. The Paris Walt sees looks just like Texas to him, and Walt should know because he has "married" Paris by marrying Ann who is "from there." For Travis, the problem of Paris runs much deeper. It is, as he later tells his brother, the place where he was conceived. And now, during Travis's rebirth, his first words, and his first image mark him in this place, "right here on the map," Paris. But on a different level, the conception of Travis Ray

13

Henderson occurs through a German/French collaboration on a movie screen. The first one to wake the unconscious Travis from his dehydration is the German Doctor Ulmer (played by the German actor Bernard Wicki). His is the first European accent to pervade the screen. The over-distinct French accent of Walt's wife Ann (Aurore Clement) is another one. And finally, Travis's own wife, Jane, is played by Nastassja Kinski, whose ludicrous southern accent parodies European images of the American rural south. The emphasis on the confusion between the two Parises and the distinctive European actors in the film accentuates the movies' own European origin of its Paris, Texas. Making the movie "foreign," or estranging the story from itself in order to emphasize the fiction as fiction, is itself a modernist strategy first theorized by the German dramatist Bertolt Brecht. By means of its *Verfremdungseffect*, *Paris, Texas* stresses the fictional quality of its representation of America.

This conflictual relationship between Paris and Texas or Europe and America gives birth to Travis. According to Travis's mother, it's the place where she and his father first made love. As he tells his brother: "I figured that's where I began, Travis Ray Henderson. They named me that. I started out there." The thematic filling in of Travis's past, moreover, transforms the cowboy without a past into a European character trying to come to terms with his past. Travis's umbilical connection to Paris, Texas links his search for a lost identity also with the identity crisis of Wenders's *Paris, Texas*. From a brochure advertisement, Travis bought a vacant lot in Paris, Texas for which, as proof of ownership, he received a snapshot of his space in Paris, Texas. To Travis, this image of the place equates with the reality and ownership of "his" origin. Travis's fragmented hold on his birthplace situates himself as a shattered individual; a photo forms just one image in the many successive images of a motion picture. The desire to own and to return to this "pure" womb of his conception supposedly will bring both Travis and the disjointed Paris and Texas together in a unified identity.

Yet the identity of Paris, Texas remains an unstable product of interpretation. Not only does the movie create "foreign" images, it focuses on the juxtaposition of different perspectives which can be placed side by side on the screen but never blend into one image. When Travis narrates his story of Paris, Texas, the screen shows his face in the rearview mirror while simultaneously showing the road his driving brother sees through the front window. Both face the road and only the spectator can view the image in the mirror and the road at the same time. The two perspectives coexist simultaneously but never blend into an image both characters can see. Only the viewer can link and literally create the whole image on the screen. The moment draws attention to the viewer as an active participant in the actualization of the fiction of the motion picture.

Perhaps the bifurcation of viewpoints is most clearly illuminated by the unbridgeable gender conflicts in the movie. The link between the ambiguity about Paris and gender conflicts in Wenders's film surfaces when Travis remembers his father's joke about the two Parises. "Daddy had a joke about it [Paris, Texas]," Travis tells Walt: "He would introduce momma as the girl he met in Paris. Then he'd wait a while before he said Texas, after everybody thought he was talking about Paris, France. He always laughed real hard about it." The joke, the spectator later learns, ceased being a joke. When Travis has to face the memory of his disastrous marriage from four years ago and Jane's current occupation at a Houston peep show, he tells his son Hunter the end of the joke about Paris, Texas: that, after his father introduced his wife as being from Paris, he would no longer correct the listener's assumption that he meant Paris, France, until, finally, his father believed it himself. Unable any longer to see his wife as she is, he can see only an image of his wife. But then Travis must confront the same error in his own marriage. His suspicion of Jane's infidelity and his own jealousy are based only on images of Jane. That she now works at a peep show called "the Keyhole Club" corrupts the vision he has of her. During his first visit, when Travis can see her through a one-way mirror, in which Jane can see only herself, Travis obsessively wants to know whether

she is also a prostitute and enacts the same jealous fantasy of four years ago. Only when he tells Hunter about his father's fantasy that his wife was not from Paris, Texas but from Paris, France, does he realize his own delusion. Although Travis perceives at this moment that his perspective violates Jane's "real" existence, his and Jane's world views remain apart.

In the climactic scene of the movie when Travis recounts his story and fills in his past life, the screen itself becomes an insurmountable obstacle. Although both Jane and Travis separately tell their stories, neither can face the other. Travis realizes that Jane cannot see him from her side of the mirror, but he still turns to face away from her. Then, after Jane recognizes Travis through the telling of his story and they darken her room so that the one-way mirror reveals itself as a transparent screen, she tells her story, also turning around, facing away from Travis. While the screen appears transparent, it serves to block a unification of stories. Travis's and Jane's stories can be told only when they refuse to confront the actuality of the other's existence. Unlike his father, Travis knows that his story fictionalizes Jane's life, yet he cannot go beyond the fiction. He leaves Jane and Hunter in order to learn more about his own identity, still fearful, as he tells Hunter on a tape-recording, of what he will find.

While the characters refuse to see one another, the viewer must bring their separate images together. Like the visitors to the "Keyhole Club," the viewer gazes at the characters through an apparently transparent screen, and subsequently creates a fiction about the characters. At the same time, the self-referentiality of the mirror-scene (only telling the story when not faced with the actuality of the other's existence) renders the screen opaque and exposes the myth-creating role of the viewer. The place *Paris, Texas* then, only unites in the view of the spectator.

As Travis drives away from Houston in search of his place, his departure becomes a critique of the possibility of a coexistence between Paris and Texas. Even though the movie thematizes its imaginary

European portrayal of America, exposing the difference does not produce "pure" Paris, Texas somehow outside of imaginary relationships. The only place for Paris, Texas exists on the screen, but that place has no mimetic relationship to an actual place in either Europe or America. As a marvellous critique of the motion picture media as realism, Walt and Ann show Travis an old super 8 film from five years ago when the two families went on a Christmas vacation to Galveston, Texas. Confronting his own image on the screen, Travis regains some of his past life. Yet the film also distorts reality by portraying a scene of domestic bliss, whereas the viewers later hear about the violence of Travis and Jane's marriage. As though it illustrates the relationship between identity and image, the camera focuses on the Travis in the film; and next on Ann, Walt, and Hunter looking at Travis, who in turn looks at an image of himself. When the home movie captures Hunter fishing at the pier, the camera next shows Hunter in the living room playing with the fish in the aquarium. As Travis turns around to look at him, Hunter says "that's me." Through the movie, Travis slowly fills in his lost identity and past life, yet the image does not form the identity. The conflict between identity and image erupts when Hunter both believes Travis still loves Jane because of the way he looks at her and, at the same time, admits that the film of Jane is not really Jane. As Hunter tells his surrogate mother: "That's only her in a movie, a long long time ago, in a galaxy far, far away." In other words, while the cinematic image influences the spectator through the way he or she looks at it, the image has an identity of its own. The complexity of the image of Paris, Texas which is alternatively transparent and self-reflexively opaque, delineates a continually transitory place. The Paris, Texas of Wim Wender's movie splits the worlds of Paris and Texas while the place itself only exists on the screen as a product of viewing. As the peep show scene illustrates, the separation of perspectives cannot be bridged.

The analysis of film critics apparently reiterates the role of the viewer in the construction site of Wenders's *Paris, Texas*. For Kathe Geist, *Paris, Texas* culminates Wender's dream of becoming an

American director. As the title of her book indicates, *The Cinema of Wim Wenders: From Paris, France to Paris, Texas* (Ann Arbor/London: UMI Research Press, 1988), she regards *Paris, Texas* as the outcome of Wenders's Americanization.

> Although the film was not officially an American production (because financed in Europe), Wenders in many ways fulfilled his fantasy of becoming an American director...[O]n *Paris, Texas* he worked with a quintessentially American writer who nevertheless had similar sensibilities to his own. Together they created an American story, with American characters in an American landscape that had caught Wenders' imagination long before he ever dreamed of directing movies.[8]

In Geist's *Bildungsroman*-like assessment about Wenders's career, she assumes *Paris, Texas* to be firmly located in America. According to the German film critic Hans Günther Pflaum, however, *Paris, Texas* tells a fundamentally European and German story. Importantly, Pflaum also projects stereotypical images of America and Europe onto Wenders's film. With *Paris, Texas*, Pflaum claims, "Wenders has succeeded in synthesizing European and American cinema, intellect, and sensuality...Despite its American setting, *Paris, Texas* turned out to be a profoundly German film, as its reception in the United States indicated."[9] Pflaum unwittingly points to the viewer's role in determining the site of Paris, Texas when he defends his claim by stressing the viewer's response. The winner of the Golden Palm at Cannes was, in contrast to its reception in Europe, not a commercial success in the U.S. Duane's response in *Texasville* to *Paris, Texas* perhaps exemplifies the movies' nonexistence in America as a "box-office hit." Kathe Geist's American view and Hans Günther Pflaum's German view expose the split perspectives of *Paris, Texas*.

In an interview about *Paris, Texas*, Wim Wenders addresses the problematic entanglement of image and life when he speaks of his de-

sire to "redefine the relationship between life and images made from life." As he tells his interviewer:

> I didn't see anything anymore that was really trying to rede-
> fine a relationship between life and images made from life.
> Whatever you go to see these days, you sit there and after
> some time you realize that you're involved again in some-
> thing that was born and has been recapitulating an experi-
> ence that comes from other movies. And I think that's a re-
> ally serious dead end for something that I love much, which
> is movies.[10]

Paris, Texas thematizes both the self-reflexivity of the film as fiction and at the same time attempts to construct a site for Paris and Texas. Wenders wants to "redefine, or find again, or rediscover what this is: to film something that exists, and film something that exists quite apart from the movie" (7). But the close-up of *Paris, Texas* can only exist as movie. The worlds of Paris and Texas remain apart as independent views.

In his next film, *Der Himmel über Berlin* (1987), Wenders again tries to unite different words, the world of the heavenly angels and the divided world of a torn Berlin, symbolic of people's earthly disasters. And again the different perspectives are linked to gender. But in this movie, the love between the stereotypical earthly woman and angelic man serves to metaphorically unite the different worlds, whereas in *Paris, Texas,* Travis Henderson remains on the road, still looking for that ideal Paris, Texas. Being on long American roads, searching for a unified European-American perspective, is the place of Wenders's *Paris, Texas.* As Travis leaves Houston behind, he gazes contentedly at his image in the rearview mirror. The title of the movie appears framed in a license plate, a moving place on the road that lies beyond the "serious dead end." Perhaps Travis's truck bears this license plate.

NOTES

[1]Alexis de Tocqueville, *Democracy in America* (New York: Vintage, 1945), 266.

[2]Peter Bromhead, *Life in Modern America* (New York: Longman, 1990), Bromhead even cites the American media's dependence on the taste of the majority as an example to Western Europe "of what should not be done" (166).

[3]Larry McMurtry, *Texasville* (New York: Pocket, 1987).

[4]Lynda Hart, *Sam Shepard's Metaphorical Stages* (New York: Greenwood Press, 1987), 122.

[5]Katherine Dieckmann, "Wim Wenders: An Interview," *Film Quarterly* (Winter 1984-5), 4.

[6]Jean Baudrillard, *America,* trans. Chris Turner (Verso, 1988), 63. Further citations refer to this edition.

[7]Henry James, *The American Scene* (Bloomington: Indiana Univ. Press, 1968), 76, 77.

[8]Kathe Geist, *The Cinema of Wim Wenders: From Paris, France to Paris, Texas* (Ann Arbor/London: UMI Research Press, 1988), 123.

[9]Hans Günther Pflaum, *Germany on Film: Theme and Content in the Cinema of the Federal Republic of Germany,* ed. Robert Pichts, trans. Richard C. Helt and Roland Richter (Detroit: Wayne State Univ. Press, 1990), 119.

[10]Dieckmann, 7.

3. DOUBLE VISION:
SCORSESE AND HITCHCOCK

Barbara Odabashian

IN AN AMAZING INSTANCE OF DEJA VU, Martin Scorsese's *Taxi Driver* (1976) was released almost two decades after Alfred Hitchcock's *Vertigo* (1958). Although *Taxi Driver* takes place at night in the rain in New York and *Vertigo* in the bright light of day in San Francisco, the two films may be mirror images. Although Travis Bickle (Robert De Niro) looks nothing like John (Scottie) Ferguson (James Stewart), they may as well be dead ringers.[1]

Travis and Scottie have in common their literal occupations. Travis (an ex-Marine) drives a cab and Scottie (an ex-police detective) wanders about in his car. At the beginning of *Taxi Driver*, when Travis is being interviewed for a job, he is asked, "So what do ya wanna hack for?" He responds: "I can't sleep nights. . . . Ride around nights mostly, subways, buses; figure, you know, if I'm gonna do that, I might as well get paid for it." When Madeleine (Kim Novak) asks Scottie what he does for a living, he replies, "Just wander about." She responds, "That's a good occupation." Because of his acrophobia he has resigned from his job as police detective, and has been hired by Madeleine's "husband," his former friend, to shadow her.

Travis's and Scottie's meanderings have in common a dreamlike quality. They endlessly circle the streets of the city—the nightmarish neon streets of New York, the surrealistic cloudless scenes of San Francisco—with no destination in mind. Ironically, as opposed to the dark rainy New York streets of *Taxi Driver, Vertigo* is played out against the background of bright sunlit scenes of San Francisco. When Scottie (aka John) wants Madeleine to tell him what frightens her about her own recurring nightmare, she says, "Being pulled into the darkness. . . ." However, the bright colors and cloudless skies of *Vertigo* are akin to the background of a surrealistic painting: nothing seems quite real or perhaps everything seems more than real. Even though Scottie tries to persuade Madeleine "it's real," not a dream, she knows better. Scottie is as much out of touch with reality as Travis (maybe even more so). In these two films, Scorsese and Hitchcock have created American heroes who are alienated from other people from the very beginning and who remain as figures of isolation in the end. Ultimately, Travis and Scottie have in common a symbolic preoccupation: anomie.

Although Scorsese does not acknowledge his debt to *Vertigo,* uncannily, he does persuade Bernard Herrmann to do the score for *Taxi Driver.* (Herrmann completed the score the day before he died on Christmas Eve. The final words of the film, following the credits, read: "Our gratitude and respect to Bernard Herrmann.") The successful and long collaboration between Hitchcock and Herrmann is justly famous, of course, and, specifically includes the score for *Vertigo.* Also in evidence is the prerequisite blonde (Madeleine/Kim Novak in Hitchcock's film and Betsy/Cybill Shepherd in Scorsese's). Scottie and Travis are both in love with the image of the blonde heroine rather than with the real woman. The two heroes admire their blonde angel from a distance and fall in love with their dream vision. When they try to touch this vision, their love is thwarted and turned to hate. They become agents of destruction and death. At the same time, ironically, they reject real blonde women (Midge/Barbara Bel Geddes and Iris/Jodie Foster) who are available to them. Their inability to interact emotionally with oth-

ers—with life—climaxes in the destruction of the lives of others and concludes with the reestablishment of their own alienation.

A third party to this cinematic "coincidence," besides Scorsese and Hitchcock, is the screenwriter/director/former critic Paul Schrader. Like Scorsese, he is extremely knowledgeable about the history of film and specifically recognizes the filmic significance of Hitchcock's *Vertigo* (as well as Ford's *The Searchers,* depicting the American hero Ethan Edwards [John Wayne], destined to be a loner, outside the circle of family and friends.) More importantly, Schrader, along with his script for *Taxi Drive,*was introduced to Scorsese by Brian De Palma, and it was De Palma who collaborated with Schrader on his next screenplay "Deja-Vu," which became the film *Obsession,* an *homage* to *Vertigo*—in his words "essentially a sort of remake of the Hitchcock film"[2] (again, with Herrmann composing the music). No matter how leading this circumstantial evidence may be, however, it still does not resolve the cinematic dilemma of the unacknowledged kinship between *Taxi Driver* and *Vertigo,* and it still does not provide an answer to an important ideological question. Why would two knowledgeable and self-conscious filmmakers (if you will, two major *"auteurs"*), apparently unconsciously, make the same film almost two decades apart?

The answer may lie in the strong sexual undercurrents in both films. The disturbing vision of the two protagonists constantly on the move, with no place to go, is a vivid representation of some strange masturbatory fantasy. The only thing that seems to bring Travis and Scottie sexual relief is the destruction/death of another, and one suspects that relief is transitory. In the driver's seat, behind the wheel of a car (perhaps a wheel symbolizing "a revolver," a gun, as it does in the Dali dream sequence in *Spellbound* [1945], Scottie meanders round and round San Francisco at a slow, measured, almost hypnotic pace, a rhythm enhanced by the anxious strains of Herrmann's score. Scottie's world consists of repeated motion as he performs his job of keeping an eye on Madeleine. It is a world where his best friend, Midge, a graphic

artist, draws an illustration of a bra "constructed on the principle of the cantilever bridge":

> Scottie: What's this do-hickey?
> Midge: A brassiere. You're a big boy now; you should
> know about things like that.

Through the half-opened slats of the blinds in the windows of his apartment we can see Coit (as in coitus?) Tower, and of course, he journeys twice to the mission tower—failing to make it to the top the first time and making it the second time, but only at the cost of Judy's life. He cannot get sexual satisfaction from intercourse with a real woman, Judy; he still longs for Madeleine, the desirable but untouchable image of a woman.

Travis, as Schrader admits his name suggests, also wanders about, keeping his eye on the blonde angel Betsy. He drives a cab at night and goes to porn movies during the day. When he finally does get the nerve to ask Betsy for a real date, he blows it by taking her to a porn flick. Then, after this moment of truth, whom does he pick up in his taxi one night but Martin Scorsese himself, playing a psychotically manic jealous husband who compulsively repeats:

> I know you must think I'm pretty sick or something.
> You know, you must think I'm pretty sick.
> Right, you must think I'm pretty sick?
> Right, I bet you really think I'm sick?
> You think I'm sick?
> You think I'm sick?
> You don't have to answer.
> I'm paying for the ride; you don't have to answer.

This compulsive exhortation will be echoed by Travis when he stands in front of a mirror, repeatedly pulling his gun (a masturbatory act), re-iterating,

> You talking to me?
> You talking to me?

You talking to me?
Well, who the hell else are you talking to?
You talking to me?
Well, I'm the only one here.

Furthermore, the Scorsese character not only invokes and extols the power of the .44 magnum and the destruction it can cause, but also directs Travis Bickle in the art of the gaze. "Scorsese" orders Travis to look up at a lighted window where he and the spectator can see the shadowy image of the wife (shades of Alfred Hitchcock). If Scorsese's dramatic presence and his direction to Travis to look up at the lighted window (in other words to look up at the movie screen) is not enough evidence that this is a film about voyeurism, or in other words, a film about film, a movie about the art of moviemaking (as are *Vertigo, Rear Window,* and *Psycho,*) there is further cinematic reference in Scorsese's signature appearance near the beginning of the film (very like Hitchcock's own appearances in his films). Scorsese is seen sitting on some steps outside the Pallantine headquarters where Betsy works, and where he watches her go into the building. At the same time, but from a protected distance, Travis is seen watching her through the window of his car. Finally, there is the spectator, watching all three of them, through the frame of the screen, from a seat in the movie theatre.[3]

Ultimately, *Taxi Driver* and *Vertigo* are about two basic themes: 1) sex and death and the primary role they play in the lives of humans, and 2) voyeurism or the art of the gaze and its primary role in the lives of filmmakers and filmgoers. In *Vertigo,* Scottie gets his sexual satisfaction from the death of Judy. In *Taxi Driver,* Travis gets his satisfaction, not from the death of the prostitute, Iris (her name evoking the image of the "eye"), but from the deaths of her pimp, the "manager" of the sleazy hotel, and her client (her "John"). In addition there is a failed suicide attempt as Travis tries to kill himself after shooting and stabbing the others. When he discovers he is out of bullets, he simply puts his bloody finger (instead of a real gun) to his head and pulls the trigger

three times (making the sound boys make when playing cops and rob-bers).[4]

When Scottie drags Judy back up the tower of the mission, he tells her they are returning to "the scene of the crime." Schrader speaks of the crime in *Taxi Driver* as the murder of the father and explains that is why it does not seem to matter to Travis whether he kills the political candidate Pallantine or whether he kills the pimp.[5] In *Vertigo,* Hitchcock, on the other hand, focuses Scottie's fear and guilt on the mother figure. The Madeleine/Judy figure is the two-sided figure of the mother: saint and seductress. (Poor motherly Midge is just too down-to-earth, and that may be why she simply disappears without explanation once the final movement of the film begins.) Either way, whether it is the death of the father or the death of the mother, the motive is clearly Oedipal.

A prominent visual image in all of Hitchcock's films is that of one hand grasping another. A positive use of this image is to show trust or love, for example, when one hand grasps another to save the other person, as in *Young and Innocent* and *North By Northwest,* when the man saves the woman by grabbing her hand to prevent her from falling to her death. A negative use of this image can be found in *Saboteur* when the hero (who himself is being held safely in the hand of the Statue of Liberty) grabs onto the spy's sleeve (rather than his hand), which natu-rally rips, causing him to fall to his death. In the first scene of *Vertigo,* following the eye imagery of the credits, we quickly discover Scottie's inability to trust the police officer and give him his hand to prevent himself from falling, even though Scottie himself is a police detective. This lack of trust in the father figure, dressed in the uniform of public authority, results in the police officer's death as he falls over the side of the building in Scottie's place. After this moment of revelation or truth, Scottie feels he must resign from the department and give up his dream to be Chief of Police. Travis, too, has trouble giving his hand to a figure of public authority or a father figure. He knows he is being patronized by the Secret Service man guarding the political candidate Pallantine,

whom he plans to kill, so when it comes time to shake hands, Travis deliberately and awkwardly gives him his left hand to shake. Ironically, although Travis expects Iris to go home to her parents, earlier in the film he lies to his own parents (in a written letter with the words spoken in a voiceover) to avoid sending them his address. It is doubly ironic, in that as a result of saving Iris, he receives the gratitude and respect of her father and an invitation (again in a written letter with the words spoken in a voiceover) stating that he would be a welcome guest in their home at any time. Of course, he will never go.

It is equally ironic that Travis is hailed as a hero by the press instead of being thrown in jail. It is clear, however, that his feeling of release (from sexual frustration) is transitory. He will explode in violence again, as evidenced by the final edgy, paranoid glances of his eyes reflected in the rearview mirror of his taxi as he drives away after depositing the angelic Betsy, whom he has picked up as a passenger, on the curb. Further violence in the streets of New York is foreshadowed in the film's final shots of his few quick furtive glances at her disappearing image, before the camera focuses on the street scenes themselves revealed through the front windshield as well as in the rearview mirror.

Scottie's final image, standing at the edge of the tower with his arms outstretched while he stares, blankly, completely enervated, is similar to Travis's state of mind and appearance at the scene of the crime after he completes the three bloody killings. These images evoke the psychic and physical aftermath of masturbatory release. Scottie is momentarily spent, but it only makes sense that he, too, will reach another "peak" of sexual frustration in the not-so-distant future.

In the schema of pathobiography, Scottie and Travis are in the end Hitchcock and Scorsese, the filmmakers, in that these characters prefer to look at the idealized image of a woman rather than interact with a real one. Hitchcock and Scorsese are indeed true filmmakers. It is their job to seek out desirable images and put them on the screen. It is the thing they care about most in life.

In some instances, the camera's role (the professional eye) vis-a-vis the spectator parallels the psychotherapist's role (the professional ear) vis-a-vis the client. Iris, the hysterical "eye" witness of the bloody violence that Travis commits, has the dubious honor of being "saved" by Travis and sent back home to her parents. The only other eyewitness is the lens of the camera, which leaves the scene of the crime on its own power. In a long tracking shot, the camera starts way above the head of Travis and moves down to the bloody walls and staircase bannister and then on to the floor of the dark corridor, and points out the gun on the floor and the gun in the bloody hand of Matthew (Sport), the pimp. Then we are outside, and the camera pulls back from the front door of the building and continues to pull away, increasing its distance from the cop cars with their revolving red lights and the medics in their white suits, slowly moving higher and farther away from the street scene. This long tracking shot recalls the famous one in Hitchcock's *Frenzy* (1972) when the camera on its own retraces the killer's steps and leaves the crime scene by backing down the stairs and out the front door. The subjective eye of the moving camera emphasizes the search for and understanding of the truth, by reiterating the key images in the attempt to clarify their meaning for the spectator and to facilitate the spectator's own recognition of the truth.

Scorsese greatly admires Michael Powell's film on voyeurism (made the same year as *Psycho* [1960]:

> I think *Peeping Tom* is very obvious. It's the interpretation of what movies are about. Not necessarily what going to see a movie is about or the effect a movie has on an audience. But I think a filmmaker would be really attracted to it because of the sense of paranoia . . . the danger of filmmaking, the danger of becoming so involved with films and looking through a lens at life.[6]

This danger of "looking through a lens at life" is reflected in the paranoia of the voyeur, so exquisitely and agonizingly depicted in Hitchcock's *Vertigo* and Scorsese's *Taxi Driver*. Significantly, this kin-

ship between the two films is made clear in the very first moments of their opening credits. Hitchcock is, of course, famous for signaling or foreshadowing the meaning of his films in the imagery of his credits— for example, the schizoid graphics of *Psycho,* the shadowy figure behind the credits of *Saboteur,* and the Merry Widow waltz of *Shadow of a Doubt.* Perhaps the most dramatic and elaborate imagery of all his films, however, can be found in the credits of *Vertigo.*

We hear the anxious strains of Herrmann's score as the title of the studio, Universal, appears on the screen; then the first image we see is a close-up of the right half of a woman's face from the lips up to the nose, placed on the left side of the screen. This image refers to the two-sided concept of the mother figure (saint and seductress) or Madeleine/Judy, and foreshadows the mirror and the doubling imagery we will be exposed to in the film. Next the camera focuses on the full image of the woman's red lips, both literally and symbolically a female sexual symbol, indicating the sexual theme of the film. The camera moves up to the nose and then to the two eyes of the face as they move from one side to the other. Also, ironically, as the eyes move to their extreme left on the screen, the spectator's eyes follow to the extreme right; then as the screen eyes move to their extreme right, the spectator's move to the left: the gaze of the spectator "mirrors" the gaze of the screen image. Finally, the eyes stare straight forward as if out at the spectator, confronting the gaze of the spectator and identifying him/her as the ultimate voyeur (as Hitchcock accusingly and sardonically does at the end of *Psycho* when he has Norman/the mother stare out at us from the screen and talk about the "they" who are "watching" him/her.

The camera moves in on one eye and then moves in even closer as the screen is flooded with the color of red and the pupil of the eye widens in fright. Out of the pupil comes the word *Vertigo* (the letters getting larger as the word moves out toward the spectator.) The movement of the titles in and out from a height throughout the credits has a vertiginous effect on the spectator. The word *Vertigo* emerges from

29

deep inside the pupil of the eye (moving first quickly and then slowly) and grows larger as it moves out towards the spectator (and at the last moment up). Then, while the screen remains red, from out of the pupil comes a swirling, rotary graphic (tinged pink), also growing larger as it moves out towards the spectator, until the graphic fills the screen and the spectator is left looking through the hole in its center as if looking through the pupil of an eye.

This image and action are repeated, alternating blue and pink rotary graphics, always ending with a widening hole in the center (both a visual and a sexual symbol, thus perfect for the theme of voyeurism). Ultimately, two blue spheres are linked together (again a doubling or mirroring) before finally turning into a stylized eye; its pupil becomes a rotating graphic which turns into another eye. The pupil of this eye (a red-tinged graphic) revolves and spins off another pupil (also red) in a kaleidoscopic effect, and retreats back into the original pupil (enlarged in fright) of the "real" eye, on a screen flooded with the color red (back to where we began). Out of this pupil of the real eye emerges the final credit: directed by Alfred Hitchcock. The line of this credit runs horizontally straight through the pupil of the eye and goes from one edge of the screen to the other. The screen fades to black and this shot is replaced by a parallel line in the first shot of the film narrative (following the credits)—the image of a steel bar running horizontally from one edge of the screen to another. The camera holds the image until suddenly we see, in extreme close-up, one hand and then the other grasp the bar. Finally, the camera pulls back and we see a man pull himself up the iron fire escape stairs onto the roof (the criminal who will be chased and lost by the acrophobic hero).

At the beginning of the credits of *Taxi Driver*, the studio title, Columbia Pictures, appears on the screen, followed by the name of the leading actor, Robert De Niro. Finally, from the darkness emerges the image of white steam filling the screen (introduced by the insistent drum beat and crash of symbols that make up the first few bars of Herrmann's moody, jazzlike score) and then the close-up of a yellow

taxi in slow motion, ghostlike (driverless), moving diagonally forward, towards the left hand corner of the screen. Following this image, the words *Taxi Driver* appear in red tinged letters against the white steam. The yellow headlights (the "eyes") of the taxi are at the eye level of the spectator, making the image appear to be looming over the spectator ("in our face," so to speak) as it emerges from the white steam and goes off screen. The effect is simultaneously eerie and claustrophobic. After the flashing of other actors' credits on the screen, alternating from the right side to the left side against the white steam, a close-up shot appears of Travis Bickle's face, from his nose to his eyes, which shift from right to left, bathed in the reflection of flashing red and white car lights (and accompanied by a solo sax line in the score). This shot dissolves into the blurred neon image of rainy New York streets at night, seen through the front windshield of the cab.

Then, more credits, and, finally, the screen is filled with wisps of red and blue tinged steam from the city streets, as through the windshield the spectator sees pedestrians cross from left to right in front of the stopped taxi. Simultaneously, the credit "directed by Martin Scorsese," appears against the red steam in the lower left hand corner where in its first appearance, the taxi cab originally left the boundaries of the screen. The penultimate image consists of an extreme close-up of Travis's eyes, completely bathed in reflected red neon light, as they slowly shift from the extreme left to the extreme right (from the spectator's point of view, whose eye movement mirrors that of the screen character). Finally, the screen again fills with white steam (as it did at the beginning). The credits then segue into the film narrative as Travis emerges from the steam, with his back to the spectator, and enters the office of the cab company to apply for the job of taxi driver. The music ends with a drum roll as Travis stands before the manager's desk and waits for him to speak:

Manager: So what do you wanna hack for, Bickle?
Travis: I can't sleep nights.

> Manager: There's porno theaters for that
> Travis: Yeah, I know. I tried that.

So the manager hires him to ride around nights, and he spends his time staring at the city and its inhabitants through the windshield of a taxi, or its rearview mirror. The spectator, too, goes along for the ride, except that he/she sits in the audience of the movie (definitely not porno) theater. Like Hitchcock, Scorsese "tricks" us into identifying with the psychotic voyeur, our eye movements mirroring his. Unlike Travis Bickle or Scottie Ferguson, however, the spectator does achieve catharsis, purely and simply, through the art of the gaze, the art of filmmaking.

In *Rear Window* (1954), Hitchcock shows a photographer temporarily behaving as if he were a Peeping Tom, and in *Vertigo* (1958) and *Psycho* (1960), Hitchcock really gets to the heart of the matter by creating protagonists who believe looking is better than living. The anxious words of the mother in Powell's *Peeping Tom* echo the concern of the nurse, Stella, and the girlfriend, Lisa, in *Rear Window:* "All this filming isn't healthy." Scorsese's response: "Maybe it isn't, but who cares." Certainly not the likes of Hitchcock and Scorsese. In Scorsese's words:

> Films are not films to me; I mean they're life. That's the idea. In other words, especially a film that reaches a certain kind of truth; you learn from it. You learn. It's like reading a certain philosophy—or trying to practice a certain philosophy from reading.

At first glance, *Taxi Driver* and *Vertigo* may seem completely different and separate, but a double take is in order. *Taxi Driver* is *Vertigo* revisited.[7]

NOTES

[1] Among the many discussions of psychoanalysis and film, I find these five works to be the most pertinent, and therefore acknowledge in advance any debt I may incur in the following discussion: Robert T. Eberwein, *Film and the Dream Screen* (Princeton: Princeton Univ. Press, 1984); Krin Gabbard and Glen O. Gabbard, *Psychiatry and the Cinema* (Chicago: Univ. of Chicago Press, 1987); Harvey R. Greenberg, *The Movies on Your Mind* (New York: Dutton, 1975); Harvey R. Greenberg and Krin Gabbard, "Reel Significations: An Anatomy of Psychoanalytic Film Criticism," *The Psychoanalytic Review* 77 (1990)): 89-110; Parker Tyler, *Magic and Myth of the Movies* (New York: Simon and Schuster, 1970).

Among the many discussions of the films of Hitchcock, Scorsese, and Schrader, I find their own words and insights provide a valuable perspective on their work, and acknowledge my debt to the three following books: Francois Truffaut, *Hitchcock* (New York: Simon and Schuster, 1984); David Thompson and Ian Christie, eds., *Scorsese on Scorsese* (London: Faber and Faber, 1990); Kevin Jackson, ed., *Schrader on Schrader* (London: Faber and Faber, 1990).

Last but not least, I am especially indebted to the structural analyses of Hitchcock made by William Rothman and Robin Wood. (See Rothman, *The "I" of the Camera: Essays in Film Criticism, History, and Aesthetics* [Cambridge: Cambridge Univ. Press, 1988], and Wood, *Hitchcock's Films Revisited* [New York: Columbia Univ. Press, 1989].) In particular, I acknowledge my debt to them as proponents of close reading (including Rothman's emphasis on "sequence reading"), film authorship, and non-scientific criticism and language (including Wood's own indebtedness to the writing of his mentor F. R. Leavis).

[2] Jackson 115.

[3]Also in *Taxi Driver,* there is the lingering shot of a film projector, seen over the shoulder of Travis when he is making a pass at the candy girl in the "Show & Tell" porno theatre. When he is rejected and turns to enter the screening area, there is a close-up shot of the film reels, followed by a shot on the theatre screen (a hand on skin) reflected in a side view mirror attached to the projector. There may even be a bit of sardonic humor at play in a final filmic reference—a Secret Service man's effort to photograph Travis is frustrared because of the interference of the crowd at a political rally for Pallantine, perhaps a reflection of the governmental authority's failure (as opposed to the cinematic artist's success) in identifying the true nature of the American hero/villain.

[4]This is yet another visual reference to fantasy or illusion taking the place of reality, just as the image of Madeleine supersedes the person of Judy. This is also why mirrors have such a prominent place in Travis's life—why we see him practicing his role as an avenger before a mirror, why he looks at life through the rearview mirror of his car, and why his face and eyes are reflected in this mirror. The mirror image represents both his confusion of fantasy and reality and a confusion concerning his true identity. The mirror, of course, plays an even more prominent role in *Vertigo,* where the many reflected images of Scottie (John) and Madeleine (Judy) again symbolize the confusion of appearance and reality and the confusion of identity, as well as the notion of the existence of a hidden dark side in humans. Ultimately, cinema itself is a mirror, in that it literally represents the confusion of appearance and reality. The technology of the medium provides a recreation of images of real objects. (See Christian Metz, *The Imaginary Signifier: Psychoanalysis and the Cinema,* trans. Celia Britton, Annwyl Williams, Ben Brewster and Alfred Guzzetti [Bloomington: Indiana Univ. Press, 1982] 42-57.) Symbolically, of course, cinema represents a reflection of our true natures. Hamlet bids his mother (III.iv.),

Come, come, and sit you down. You shall not budge.
You do not till I set you up a glass.
Where you may see the inmost part of you.

Similarly, it is Norman Bates's accusing eyes staring out at us from the screen that make us see the "black and grained spots" in the "very soul" of all humans.

5Jackson 119-20.

6Steven Fischler and Joel Sucher, dirs., *Martin Scorsese Directs* (American Masters, 1990). All of Scorsese's comments on *Peeping Tom* and filmmaking in this article are from this documentary film.

7I wish to dedicate this piece to Pauline Kael on the occasion of her retirement as the regular film reviewer for *The New Yorker.* Her exciting words and ideas on films through the years have charged my passion for the movies, and I will miss her presence as a regular reviewer sorely, since I have always eagerly awaited the appearance of her lastest column on a "hot" new film release. (See Kael's *New Yorker* [9 February 1976] review of *Taxi Driver,* reprinted in *When the Lights Go Down* [New York: Holt, Reinhart and Winston, 1980] 131-35.)

4. TRANSFORMATIONS OF TERROR: READING CHANGES IN SOCIAL ATTITUDES THROUGH FILM AND TELEVISION ADAPTATIONS OF STEVENSON'S *DR. JEKYLL AND MR. HYDE*

Brian Rose

THIS PAPER WILL EXPLORE part of what can be learned regarding the use of continuous adaptation of a single text as a "barometric" guide to shifts in popular attitudes toward social issues; I will do so through an examination of major film and television adaptations of Robert Louis Stevenson's *The Strange Case of Doctor Jekyll and Mister Hyde*. I will explore why this particular narrative is valuable for tracking changes in social attitudes as what I term a "tracer text," which may be defined as a narratological construct or story that possesses both mythic and entertainment value to its adopting culture, and is revealed as psychologically important to that culture by its continuous reutilization in performative forms over an extended period of time, utilizing the media that might be expected to reach the largest possible number of interested members of society. After positioning the Jekyll and Hyde narra-

tive as such a tracer, I will explore what performative adaptations expose concerning attitudes regarding the relationship of science to society, and the iconographics of the typology of evil, although many other themes lend themselves to such analysis. To do so, I will utilize six relatively close adaptations of the Stevenson text: the Barrymore, March and Tracy film versions of 1920, 1932 and 1941, respectively, and the Michael Rennie, Jack Palance and Michael Caine television versions of the mid-1950s, 1968 and 1990.

I have adapted the term "tracer text" from medical technology. Just as a radioactive isotope can be injected into a body in order to collect in tumors and reveal their existence, a tracer text is one that, regardless of its national or generic origins as a novel, story or folkloric tale, is appropriated by a culture and transformed into performative media due to its plot's or tropes' archetypic importance and entertainment potential; the adopting culture then chooses to auto-inject the narrative periodically into the segments of the social mind through readaptation or performance in new, reformatted productions. The injected text then fulfills the need for its injection through its service as a matrix for the carrying of expressions of social anxieties, which are crafted in and detectable as structural and dramaturgical changes from the original narrative. The impact and cultural importance of specific tracer texts can be gauged as a function of the number of reuses of and narratological forms the story takes. Usage of the tracer at various points in a culture's life to encode specific social attitudes can be analyzed to reveal issues of interest and social concern—social tumors, if you will, the etiology of which changes from one adaptation and period to the next. I concentrate on performative recycling in this work, but tracer texts of great cultural importance and usage will also be recycled in forms other than the performative: new novels based on the themes and characters, short stories, or as new editions with different iconographic patterns expressed through illustrations. Examples of tracer texts within our own culture are *Hamlet, A Christmas Carol,* Conan Doyle's Sherlock Homes corpus, *Frankenstein* and *The Strange Case of Dr. Jekyll and*

Mr. Hyde, which has received over seventy performative adaptations in all media during this century.[1]

Leaving aside the obvious entertainment value of the Jekyll and Hyde story, proven by its countless reproductions, versions and perversions, its potency as a tracer narrative is involved with its function as contemporary myth and its capacity for providing structures and tropes both appropriatable and palatable to contemporary usage.

Stevenson's tale has inspired frequent performative adaptations throughout the twentieth century, due not so much to its content of terror or suspense, as to its function as a legitimate myth for our culture. In the senses of being a "way of service" and "an ethnic idea,"[2] in Joseph Campbell's terms, it is an oft-told tale providing insight into archetypic imagery relevant to our culture, and as such, it encodes information both portentous and prophylactic, so much so that the term "Jekyll and Hyde" has entered our vernacular as a cautionary pejorative.

Campbell defines the "way of service" and individuating, familial functions of mythic imagery in this manner:

> Functioning as a 'way,' mythology . . . conduce[s] to a transformation of the individual, disengaging him from his local historical conditions and leading him towards some kind of ineffable experience. Functioning as an 'ethnic idea,' on the other hand, the image binds the individual to his family's system of historically conditioned sentiments, activities and beliefs, as a functioning member of a sociological organism . . . the force of the mythological symbol itself . . . is, precisely, to render an experience of the ineffable through the local and concrete, and thus, paradoxically, to amplify the force and appeal of the local forms even while carrying the mind beyond them.[3]

The Stevenson narrative encodes and enacts these specific functions by focusing on the literal transformation of the individual. It does so by juxtaposing the horrific and mysterious qualities of Jekyll's transformation against the banal backdrops of the "men's club" atmosphere

of Victorian London and the limited perspectives of Dr. Jekyll's contemporaries. In addition, there appear in all adaptations artificially constructed social, sexual and familial relationships contrived for Jekyll. The adaptations may therefore be seen to fulfill Campbell's functional definition of myth by eliding mythic constructs with the socio-familial. For adaptations from the 1960s to our own time, these constructs occur within a NeoGothic performative context.[4] Aspects of NeoGothicism prevalent to the popularity of *Jekyll and Hyde* as a performative form are the "reinscription of the melodramatic within a framework of extreme realism, the assertion of the horrific against a backdrop of the reassuringly banal, the conscious breaking down of order, the use of circular as opposed to linear plot movements, and problematic closure."[5] One can, as well, detect in Stevenson's narrative aspects of the advent of theatrical Expressionism, at least as described by Strindberg in the preface to *A Dream Play:* "The personalities split, take on duality, multiply, vanish and disperse and are brought into a focus."[6] Thus, it is not only the mythic and archetypic qualities of plot that account for the story's importance as a cultural tracer, but structural aspects of the narrative that align it to both resurgent and emergent discourses in the development of the century's artistic modes of expression.

As a narrative, the original novel by Stevenson can be seen as a transitional form between the earlier, Gothic novel and what has since become known as science fiction. In addition, because the roots of science fiction lie embedded in the Romantic movement of the late eighteenth and early nineteenth centuries, aspects of the narrative, such as the protagonist's struggle with the forces of nature and opposition to dominant social discourses, refer back to the narrative's roots in that earlier school. Although it is dangerous to indulge in "retroactively recomposing [the] text under the influence of a generic idea that did not come into being until well after it was written,"[7] the fact that the narrative contains families of themes and structures later featured in science fiction provides a justification for modern appropriation and recurrent utilization of the "mythos" of the tale.

Another reason for the appropriation of this mythos as a tracer text is its placement within the milieu of the Victorian era of London. The Victorian era embodies, in Umberto Eco's words, the rise of our modern vision of:

> merchant cities, capitalist economy (along with banks, checks and prime rates) . . . the rise of modern armies, of the modern concept of the national state, as well as the rise of a supernatural federation; the struggle between the poor and the rich, the concept of heresy or ideological deviation . . . love as a devastating unhappy happiness . . . the technological transformation of labor.[8]

These qualities, noted by Eco in reference to the current fascination of popular culture with things medieval, are equally, perhaps even more, appropriate as an explication of Victorian nostalgia, and provide specific parallels with the Jekyll and Hyde narrative that make it attractive for twentieth century appropriation. Certainly, Jekyll and his moral-scientific search (as perceived by adapters and popular audiences) corresponds to his society's vision of ideological deviation, and the narratological value of love as "devastating unhappy happiness" provides adapters with a justification for the intrusion of a variety of complicating sexual relationships that Stevenson did not see fit to include and which reflect the anxieties and social concerns of the adapters. In addition, the Neo-Malthusian qualities of the original narrative provide a complex collection of referentials specifically clustering around the perception of the battle between good and evil as being evolutionary. This Neo-Malthusianism offers the opportunity for implicit assumption of a Darwinian (or Social Darwinistic) superstructure that provides justification for the appropriation of the narrative, and enhances its usefulness as a contemporary "meta-myth" within which a variety of intricately interrelated economic, class, gender and racial concepts may be subsumed and utilized.

In Stevenson's novel, Jekyll's character is more problematic than popular adaptations portray. References are made to the illicit pleasures

of youth that caused a hardening of Jekyll's character into a firm duplicity, and Jekyll's "goodness" is seen as a repressive activity.[9] Jekyll gradually transforms his own personal duplicity into a metaphysical doctrine of the duality of the human soul, which leads to his experiments. Jekyll, symbol of selfless good in popular adaptations, is a hypocrite, albeit well-meaning and tortured. No major media adaptations of the mythos utilize this ambiguous moral nature of the central character, opting instead for a more classically derived crypto-tragic structuring that allows a clearer positioning of ideological issues when cast into performative, mimetic form. Jekyll's perceived qualities as scientist (desire to explore the unknown, desire to benefit humanity) are transformed by adapters from motives both ambiguous and self-serving into *hamartia,* or tragic flaws. That is to say, he is perceived by adapters and their audiences as a "good," or to be more properly Aristotelean, "noble" character who makes mistakes in judgement that bring about his destruction because he chooses to engage in a battle both with the forces of nature (seen by his opponents as divinely ordained and sacrosanct) and a social order that is defined by its opposition to his ideological subversion. Thus, while for Stevenson, Jekyll's destruction may be seen as the inevitable if pathetic consequences of a duplicitous life and facade of social hypocrisy cast, in Stevenson's words, in the form of a "fine bogy tale,"[10] for popular adapters his destruction is read as a reinscription of antiscientific attitudes and a rejection of the discourse of rational materialism in favor of one of prescriptive social metaphysics. Jekyll's opponents are ultimately proven correct, but not for the correct reasons.

Chaos theory plays a large part in Stevenson's mythos; Jekyll's experiment works only because of random error, the presence of an undetected impurity in the final ingredient of (as Nabokov has referred to it) the "chameleon liquor"[11] that effects the transformation, and it is the undetected presence of this impurity that ultimately leads to Jekyll's destruction. This element in the original narrative is absorbed by all adapters but undwelt upon as an important structural element. Instead, it

is utilized by them a collusionary manner, through its unity with the pseudo-tragical transformation of Jekyll's character in such a way as to make him more effective as a mimetic symbol, at the expense of the original narrative's more ambiguous positioning of Jekyll's moral stance and technological prowess. Jekyll's experiments are, then, however thematically meaningful as *dianoia,* meaningless as *praxis* and pointless as true science, being unreplicatable. The imposition of pseudo-tragical structures upon the narrative by adapters results in an obscuring of Stevenson's complex examination of the role and nature of science, in favor of a theatrically enhanced vision of the scientist as sacrificial victim, which is then utilized by adapters for their own social purposes.

Operating at the same time as this overlaying of tragic structure are the functional structures of horror literature, a conservative reinscription of norms that is, as Stephen King has pointed out, "as Republican as a banker in a three-piece suit. . . . [They have] the effect of reconfirming values . . . self-image and our good feelings about ourselves."[12]

> We love and need the concept of monstrosity because it is a reaffirmation of the order we all crave as human beings . . . it is not the physical or mental aberration which horrifies us, but rather the lack of order which these situations seem to imply.[13]

Horror theoretician Noël Carroll has pointed out that "the horror story is always a contest between the normal and the abnormal such that the normal is reinstated and, therefore, affirmed. . . . The abnormal is allowed center stage solely as a foil to the cultural order, which will ultimately be vindicated by the end of the fiction."[14] The horror tale therefore provides a useful template for ordering the reinscriptive tasks Campbell assigns to myth; those tales rooted in the Gothic and NeoGothic contexts or Victorian milieu allow a variety of comfortable socio-psychological associations for twentieth-century audiences.

Jekyll is consistently portrayed in adaptations as searching for that which will liberate the human from the evil within, thus raising the human quotient of evolutionary adaptability; in so doing, however, he places himself in direct opposition to the opinions of his critics, who see such efforts as an attack upon the metaphysics that form a foundation of their vision of the nature and proper function of society. One might think that Rosemary Jackson's description of the horrific as primarily subversive is being vindicated here,[15] but, ultimately, as King and Carroll have pointed out, the innate conservatism of the horrific (and of myth) must be preserved: the conservative forces are proven correct by Jekyll's failure and destruction, which, as we have seen, has been remodeled to contain heightened mimetic energy at the expense of Stevenson's more ambiguous vision of Jekyll's character and purposes. Thus, science as a secular humanistic search, at least in its more radical forms, is rejected, and socio-familial standards of traditionalist theological thought reinscribed; or, rather, the boundaries of science are proscribed to fit within the paradigm of the dominant social metaphysics by a narratological collusion of crypto-tragic formatting and the innately conservative, reinscriptive task of the horrific as a genre.

In the 1920 silent film version starring John Barrymore, any agony between Jekyll and the forces of establishment science is given short shrift, due firstly to the constraints of the medium of silent film, and secondly to the casting of the adaptation in the mold of a domestic melodrama which concentrates on the personal paradigm surrounding the character. Dialogue, of course, is restricted to single lines projected on the screen as interruptions of the pictorial action, and is kept to a minimum. The first image in the film is Jekyll peering through a microscope at swirling (seemingly battling) bacteria; his single foil, sitting bored in a chair, immediately rejects his efforts as being pointless, impossible nonsense, to which Jekyll responds with a single line about the proper role of science as exploration. We see, then, that even at this early point in the century's adaptive process of narratological recycling, the scientist is already being positioned as alien to his greater social and

domestic milieu. The role of science, however, is not being overtly questioned; it is, rather, being ignored, and the film becomes one about the ultimate degradation of Jekyll by the subversive effects of his immersion in vice, leading to a film with little impact beyond that of a domestic melodrama detailing the effects of, say, demon rum.

By the time of the Rouben Mamoulian/March version of 1932, the expanding role and importance of science as a dominant mode of social discourse has forced corresponding narratological expansion: the film begins with a young Jekyll (itself a significant adaptational departure—Stevenson's Jekyll is middle-aged) addressing a gathering of doctors and scientists (half of whom are young and half old). The youthful members of the audience are in sympathy with Jekyll's radical concepts of the role of science as an exploratory aid to the evolutionary process, and the taking of that process into man's hands through investigation and experiment; the older members, iconographic representations of an earlier era's conservatism in scientific thought, reject him utterly. In this most complex and satisfying of extant media adaptations, the lines of battle are clearly drawn: science is dangerous, and its power, elided with the very concepts of sin and evil, is tempting. The Mamoulian version also contains intriguing linkages between the conservatism of scientific dogma, dominant socio-familial discourses, and the military: this is the only version in which Jekyll's symbolic social antagonist is a military man. He is, in this plot avatar, the father of a woman Jekyll wants to marry, and imposes an arbitrary eight-month wait upon him. Jekyll requests that it be removed, remarking that General Carew's fiat is insufficient cause for such a wait. The General responds: "Is this another instance of your eccentricity? It isn't done, sir; it isn't done." The whole system of social constraints represented by the dominant societal discourse, which includes reliance upon socio-theological dogma rather than investigation as truth-finding techniques, and the arbitrary imposition of domestic constraint by age over youth, is linked to a rejection of Jekyll's scientific radicalism and, in turn, tied to an iconography of militarism—interesting reflections coming from an adaptation created

45

between one world war and the looming possibility of another. This results in a depiction of the phenomenological nature of evil as being a rejection on Hyde's part of constraints upon sexuality, stopgaps to personally-motivated violence and socio-familial principles. This is captured iconographically in a montage of swirling images occurring at the moment of Jekyll's first transformation, a motif later reutilized to different ends by director Victor Fleming in Tracy's version. This is a far more complex depiction of the operations of evil than that possessed by other versions, which tend to focus evil as an expression of sexuality (Barrymore and Rennie), psychosexual sadism (Tracy) or a more pure admixture of sadism and violence (Palance and Caine). Stevenson's narrative suggests that Hyde's primary expression of phenomenological evil is an indulgence in sadistic homoerotic activity. Leaving aside the question of social influences that forced Stevenson to cloak this vision of evil in nondiscursive terms and images, it is meaningful that adapters, most notably (but not only) those involved in the most "Hollywood" version of the narrative, Victor Fleming's 1941 version, find the substitution of psychosexual sadism directed against women to be a more palatable, popularly acceptable substitute. It is interesting to note, in passing, that the adaptations focusing on sexuality occur in periods of cultural sexual repression or in a transitional period out of such a time (1920 and the mid-1950s); psychosexual sadism is the theme of the adaptation occurring during the expansion of Freudian ideas into popular culture (1941); and violence is the main expression of evil during the adaptations of 1968 and 1990, both occurring during periods of cultural self-doubt related to the rising tide of socially motivated violence and the breaking down of traditional familial structures.

Interesting economic qualities enter the equation by the time of Spencer Tracy's adaptation, made in 1941. There is no agony, or dramaturgically modelled conflict, between Jekyll and scientists in this film; rather, the exposition of Jekyll's views takes place over a huge elegant dinner table at which sit various representatives of the powerbro-

46

kers of society, including established science, business and the church. There is a discussion of the moral implications of Jekyll's work that grows more and more heated, again centering upon arguments revolving around conflicting visions of the role of science as servant of man's evolution, versus a vision of science as domesticated discourse in service of theocratically inscribed social systems. It is Jekyll's final remark to a leading physician that breaks up the discussion: that his techniques for isolating and removing the element of human evil from society are opposed because there is "comfortable profit in those already established." Here, a culture about to be immersed in an ensuing world war reveals an intimation that the status quo has strong economic self-justifications for a continuing ignorance of itself and its culpability in the generation of evil.

The 1968 television version starring Jack Palance begins with a major agonic debate between Jekyll and the powers of authorized science: he is situated at the bottom of a well-like auditorium, surrounded by middle-aged and aged practitioners. The scene begins in the midst of a violent verbal confrontation that ultimately degenerates into near mob violence, which is utilized by the scriptwriter to provide Jekyll with a final, clear motivation for the continuance of his research. Jekyll's notions and purposes, clearly positioned as evolutionary, are loudly ridiculed, and the notion of evolution is itself lambasted. This is a reference, on scriptwriter Ian McLellan Hunter's part, to the anti-evolution hysteria of Victorian London (more a literary artifact than one of science history), but for narratological purposes it clearly describes a fear of scientific process on the part of the established societal order, elided with a revelation that the popular audience of 1968 can be expected to regard science as a terrifying process that requires reconscriptive controls. We are cautioned by a voiceover narration at the opening of this version: "It has been said that many men have found their way through the valley of violence to the palace of wisdom. But if all men must learn wisdom tomorrow through violence today—then who can expect there will be a tomorrow?" The popular version of this tracer

47

narrative in 1968 elides a fear of destruction through violence with the operations of science, a vision confirmed by the graphically depicted violent sadism of the actions of Palance's Hyde.

Twenty-two years later, the 1990s version, starring Michael Caine, has accepted, as has society, the ubiquity of science and its inherently amoral, secular nature; instead, it casts the onus upon choice of technique, rather than moral philosophy. In this version, Jekyll is condemned for advocating drug experimentation and usage for the ends of evolutionary development, instead of the more conservative "steady state" techniques of established science, with its implicit software technologies of moral/psychological control and counseling for the eradication of evil. It is also interesting to note that this is the only version of the story in which Jekyll is specifically portrayed as being a member of a university faculty (although he seems to be some sort of guest lecturer in the l932 March version), thus tying the higher education industry to the camp of dangerous radical factors requiring control. The adaptation continues the "youth/age equals radical/conservative" dichotomy touched upon in the March version, adding a "fear of youth" message to the reinscription of conservative norms encoded in Jekyll's carefully crafted, crypto-tragic downfall.

Of particular interest is the iconographic representation of evil in the form of Mr. Hyde: the choice of Hyde's image provides direct insight into a popular culture's vision of evil as it relates to their willingness to either accept it as their own, or disown it. In Barrymore's 1920 version, Hyde is portrayed as insectlike, specifically spiderish:[16] elongated, twitching fingers, tube-like mouth and conical head on a misshapen, bent body. In such a portrayal, evil is being disowned as an immediate human quality: evil is somewhere deep within our being, accessible only through the radical operations of science—it is not close enough to the psychic surface to worry about as a spontaneous danger. In Mamoulian's 1932 version, the form that evil takes is anthropoid: thickened brow, excessive hair, vicious, jagged teeth, jerkily energetic in movement. Evil is still being distanced from the truly human, but

now the image is of our cousin, the ape. Evil is being foregrounded as something that we have outgrown, in an evolutionary sense, except for our use of illicit scientific techniques to release its power. As we advance closer to our own decade, there is iconographic evidence that we are being forced to move closer to embracing the idea that the face of evil is our own, and thus lies closer to our own psychic surface, awaiting nascent release.

By Tracy's adaptation in 1941, Hyde's form is distinctly human: sinisterly dark and not without a sensual attractiveness. No overt shade of the animal remains: Hyde is one of us. By the 1950s and 60s, in television adaptations starring Michael Rennie in a script by Gore Vidal, and Jack Palance in a script by Ian McLellan Hunter, the human face of evil is entrenched. Both versions portray Hyde as a stylish, if obviously threatening man-about-town, concerned with his appearance, affecting a Hydeish sense of costuming style. There is no way that one would assume one is looking at an unhuman creature, or monster, by seeing them. Rennie's Hyde bears iconographic resonances with the contemporary popular conception of the Neanderthal, indicating that evil is still being held as retrogressive. But by 1968, in the Palance version, with its overt concern for the equation of evil with violence, Hyde looks like Gregory Peck with joined eyebrows. Thus, for the audiences of the 1940s, '50s and '60s, terrified perhaps by the social ramifications of the rampant spiral of war, social upheaval and, ultimately, mutually assured destruction, there is no escape from the conclusion that evil is self-generated, comes from within us and bears our face; further, its expressions are style, sexuality and sadism, as opposed to the violently chaotic, animalistic actions of March's Hyde or the cringing, skulking vision of Barrymore's. As Prospero says of Caliban, "This thing of darkness, I acknowledge mine."

In our own time, the circle has come round again, and in a most intriguing manner. Since 1968, we have lived with and seen exponentially exacerbated the social problems bearing the emblematic label of "evil" that we may once have optimistically hoped to conquer. Yet Hyde, in

Caine's 1990 version, is once again alien to us. In this version, produced for the largest mass audience available in the tracer's history, only the most literal iconography of alienness will do: his appearance has been appropriated from the iconography of xenophobic variations of science fiction. Huge in size, pale in color, scrofulous of skin texture, with a totally bald head divided into two distinct lobes when seen from the rear, distorted of feature, almost amorphous of face, this Hyde could never be confused for human. Evil is being disowned, perhaps emblematic of the manner in which we have refused to take responsibility for the political, social, economic and technological evils we have ignored or allowed to proliferate. Most interesting to note in this context is that in all performative adaptations considered from the 1920 Barrymore film to the 1968 Jack Palance television version, the conservative values of society are reinscribed by the death of Jekyll and destruction of Hyde (positive, unambiguous closure, further signifying the Ascension of the deceased, crypto-tragic hero to the eschatological heights of forgiveness through death), but by the 1990 Michael Caine television version, evil clearly triumphs: Jekyll, his DNA altered by the ingestion of the formula, has fostered a child by rape —the final shot of the film is the revealing of his existence and a close-up of his face, a hybrid of human and Hyde. Thus, not only do we find our own culture dealing with the question of evil through lack of closure; that lack of closure is supported through pseudo-scientific justification by a society further choosing to disown evil itself via a totally alien iconographic representation of Hyde. The structural constellation created here is most complex: evil exists, its existence released by the actions and philosophy of radical science; once it is released, it cannot be controlled and yet, as humans, we disown it—it is apart from us, has its own life, and bears not our face.

Stevenson's *The Strange Case of Doctor Jekyll and Mister Hyde* is "one of those rare stories that most readers think they know, even if they have never read it."[17] But it is surely obvious by this point that the story we think we know—which is actually the culture-text created by

interaction of text, adaptations, and the popular mind—is a shape and meaning-shifting thing, redesigned subtly by its adapters to encode time-bound social interpretations of archetypic concepts which reveal how we think and feel. Just as Stevenson's original narrative, far from being a mere "bogey tale," or simplistic morality of good versus evil, reveals itself upon examination to be more intricate and subversive, so it is that the simplistic positioning of science and its search as the triphammer that releases evil is far too simplistic a response to the existence of a constellation of human problems to which we assign that descriptive label.

NOTES

[1] For a useful listing that ends around 1980, see Harry M. Gieduld, ed., *The Definitive "Dr. Jekyll and Mr. Hyde" Companion* (New York: Garland Publishing, 1983).

[2] The term "ethnic" has values for our contemporary culture not anticipated by Campbell, specifically those involved with the perception of hegemonic dominance of minority groups by majority or empowered groups. I use the term here as I believe Campbell meant it to be used: as one that refers to the sets of values possessed by discrete social groups larger than, but subsuming, the familial and clan groups within which individual lives are embedded.

[3] Joseph Campbell, *The Masks of God: Primitive Mythology* (New York: Viking Press, 1969, 462.

[4] cf., Marybeth Inverso, *The Gothic Impulse in Contemporary Drama* (Ann Arbor: UMI Research Press, 1990).

[5] Inverso, 19, 28.

[6] August Strindberg, "The Author's Preface," *A Dream Play*, in *A Treasury of Theatre from Henrik Ibsen to Robert Lowell*, John Gassner and Bernard Dukore, eds. (New York: Simon and Schuster, 1970), 2:171.

[7]Mark Rose, *Alien Encounters: The Anatomy of Science Fiction* (Cambridge: Harvard University Press, 1981), 5.

[8]Umberto Eco, "The Return of the Middle Ages," in *Travels in Hyperreality,* trans. William Weaver (New York: Harcourt, Brace Jovanovich, 1986), 64.

[9]Robert Louis Stevenson, *The Strange Case of Dr. Jekyll and Mr. Hyde* (Oxford: Oxford University Press. 1987), 60-6l.

[10]Qtd. in Jenni Calder, *RLS: A Life Study* (London: Hamish Hamilton, 1980), 220.

[11]Vladimir Nabokov, *Lectures on Literature*, Fredson Bowers, ed. (New York: Harcourt Brace Jovanovich, 1980), 180.

[12]Tim Underwood and Chuck Miller, eds., *Bare Bones: Conversations on Terror with Stephen King* (New York: McGraw-Hill, 1988), 9.

[13]Stephen King, *Danse Macabre* (New York: Berkeley Books, 1987), 39. Both quotes from notes 12 and 13 are qtd. in Carroll, below.

[14]Noël Carroll, *The Philosophy of Horror, or Paradoxes of the Heart* (New York: Routledge, 1990), 199.

[15]ef. Rosemary Jackson, *Fantasy: The Literature of Subversion* (London: Methuen, 1981).

[16]I am in Prof. Carroll's debt for pointing out to me that there is an extended discussion of this man/spider iconography of Barrymore's Hyde in James B. Twitchell's *Dreadful Pleasures: An Anatomy of Modern Horror* (New York: Oxford University Press, 1985), 245-246.

[17]Richard T. Gaugham, "Mr. Hyde and Mr. Seek: Utterson's Antidote," in *Journal of Narrative Technique* 17:2 (Spring, 1987), 184.

5. DECENTERING THE SUBJECT: DAVID HARE'S *WETHERBY*

Nicholas O. Pagan

> Je mens. Et je dis la vérité.
> Elle, in *Hiroshima mon amour*

WRITTEN AND DIRECTED BY DAVID HARE, *Wetherby* (1985) is part of the impressive surge in British filmmaking which has been evident over the last decade or so. Although it is possible to see a connection between *Wetherby* and films like *A Passage to India* (1984) and *Pascali's Island* (1988) which deal to some extent with the waning of Britain's colonial past, it seems easier to link *Wetherby* to films like *My Beautiful Launderette* (1985) and *Sammy and Rosie Get Laid* (1986) which concern themselves with issues generally closer to home.[1] Hare, who comes to filmmaking after extensive experience with writing for the theater, has encouraged social and political readings of *Wetherby* by suggesting that "Although in *Wetherby* [his] political purposes are a great deal more concealed than in some of his stage work, they are there."[2] We should not be surprised, then, to note that the most pervasive critical treatment of Hare's work has focused on his political and social concerns.[3]

Here I will suggest that although these political and social concerns may indeed be characteristic of *Wetherby,* the hasty (or not so hasty) leap to thematicism tends to ignore the way in which the film is constructing its objects rather than attempting to truthfully reproduce a so-called "real" world. I do not doubt Hare's sincerity when he says that "in *Wetherby* and *Plenty* [for which he wrote the screenplay]. . . . I'm obsessed with the cost of telling yourself or not telling yourself the truth. Choices of honesty."[4] I maintain that *Wetherby's* prime concern is its own nature as film. In fact, montage, or more specifically the play involved in montage, takes precedence over any possible thematic center.

Wetherby distinguishes itself from most British films of the period by looking back to many of the techniques of the French director, Alain Resnais, and in particular films like *Hiroshima mon amour* (1959) and *L'année dernière á Marienbad* (1961), films that employ the Proustian technique of recapturing and reconstituting a fragmentary past, but seem almost willfully to defy any attempts to define their "real" subject. Like Resnais' films, Hare's *Wetherby* draws attention to its own use of what the French narratologist Gerard Genette calls "anachrony." Genette describes anachrony as indicating the discordance between the temporal order of the events of the story (*histoire*) and those of the narrative (*récit*).[5]

Although one may see the all-pervasive use of anachrony as drawing attention to the manipulating hand of the writer-director, the film more obviously draws attention to itself as montage or "the successive concatenation of different scenes [episodes]."[6] Because the scenes in *Wetherby* are so fragmented, montage here involves a concatenation of fragments; that is, parts of scenes, for no scene seems to be presented in its entirety without interruption, or to be more precise, without anachrony—either in the form of flashback or flashforward.[7]

Wetherby is divided or may be divided into five time periods. The time period with which the film begins (let us call it tentatively the

first time period because it seems to be the most recent in time) involves a man (Stanley Pilborough) and a woman (Jean Travers) pondering the difference or lack of difference between the terms "lawyer" and "liar" as they discuss a mutual friend called Nixon. We hear this conversation beneath the credits and then see the two of them sitting in a pub. The name "Nixon" of course calls to mind President Nixon who in fact will appear on a TV screen later in the film. The second time period involves the events following the dinner party— including John Morgan's suicide and the aftermath of the suicide. This time period ends with Jean's final revelation to Mike Langdon concerning the incident involving her and Morgan which takes place in her home the night of the party. Jean will then return to her teaching duties, and the film ends in this time period with Jean and Stanley again sitting in a pub (they are wearing different clothes this time, have different drinks, and Jean's hair style is different—all signs that this is not the same time period as the opening sequence). The end of the second time period (which is also the last scene of the film) involves Jean explaining to Stanley that one of her students ran away that day. Stanley makes a final toast "To all our escapes." The third time period begins with John Morgan's appearance in *Wetherby* and involves the events leading up to and including the dinner party and ends with the departure of the guests. The fourth incorporates scenes involving John Morgan and Karen Creasy at the University of Essex, and the fifth, which takes place in the most distant past, involves the relationship between Young Jean and boyfriend Jim Mortimer; it ends with Jim's death in Malaya.

Sometimes because of an absence of clear temporal indicators, the audience may be unsure whether they are in an anachrony or not. Immediately after John Morgan's suicide in Jean's home, for example, there is a direct cut that takes us back about thirty years to a scene where Jean (a girl) and boyfriend Jim are making love in a troop carrier. Jean the adult crying "No! No!" in response to Morgan's suicide (in time period 2) abruptly gives way to Jean the girl crying

"Yes! Yes!" in response to Jim's love-making (in time period 5). On seeing the film for the first time, we may think of this girl as another character in the movie, and the lovemaking could be occurring at the same time or during the same time period as the suicide. Movements into and out of flashbacks then are not always clear although they become clearer as the film progresses.

Perhaps we should consider the second time period to be the main narrative because it is referred to in the published script as "the present." The "present moment," says Genette, "is the moment in the story when the narrative was interrupted to make room for the anachrony·"[8] The second time period is the one given by far the most running time. It contains by far the largest number of fragments and it is the time period most frequently interrupted. It is perpetually interrupted by flashbacks to the third time period (the dinner party) and the fifth (Jean as girl and boyfriend Jim). We may well ask though whether the other time periods should be defined in terms of this one, as this one is itself retrospective. Most viewers, of course, would not read the published script and would therefore not know that this time period has been designated "the present." The film, then, may be seen as taking place in a perpetual present or a presence in which the different time periods compete for presence, for preeminence, for meaningfulness.

As in Resnais' *Hiroshima mon amour,* the flashbacks are generally seen from the point of view of one particular character. In *Hiroshima,* this is generally the French woman taking us back to Nevers, the scene of her youth, her experience of first love with a German soldier, the shaving of her head, her incarceration in the cellar, the tragedy of lost love. In *Wetherby* Jean's flashbacks are also to the scene of her first and tragically lost love (time period five), but also to the scene of the party (time period three). In both films, the flashbacks are prompted by the woman's emotional state and by questioning phrases or looks from an interested male: Langdon in *Wetherby,* the Japanese lover in *Hiroshima.*[9] In *Wetherby,* the more that we flash back to the party,

however, the more we may sense that something is being left out. Gradually we, like the detective, Mike Langdon, are able to make some sense of what happened at the party; but we, again like Langdon, are frustrated because we do not know why Morgan committed suicide or why he committed suicide in this particular place. Why did he choose Jean? What is the connection between Jean and John?

After John Morgan's suicide the sudden transition to Jean as a girl may suggest that the link between Jean and John is more than the homonym in the proper name—clearer when the names are pronounced in French. In a fragment involving the two characters together on the landing as the party continues downstairs, John Morgan suggests connections for us: "You're in trouble. Like me," he whispers to Jean. "You and I—we understand each other. . . . You've been here where I am." Indeed, Jean will later suggest to Marcia Pilborough, "I think the lonely recognize the lonely," but surely the connection is more than a question of loneliness. Perhaps this place where Morgan claims Jean has been is a state of mind. Perhaps it involves an inability to feel which Morgan translates elsewhere into the thought that "you might as well be dead." Here, on the landing, Morgan senses that Jean's cheerfulness is faked: "All that hope coming out of you. All that cheerful resolution. All that wonderful enlightenment. For what? For nothing. You know it's for nothing. Don't tell me that all that cheerfulness is real." Later in the story (*histoire*) after Mike Langdon's live-in girlfriend leaves him, Langdon suggests to Jean, "it turns out I was a subplot. The real story was happening elsewhere." This is the viewer's problem: In which time period is the "real story" taking place? Surely, it is in the shuffling or reshuffling of the story (*histoire*) itself. The real story is to be found in the gaps produced by the temporal reordering. The "real" story is inseparable from the "reel" story: the creative use of montage.

David Bordwell points out that in films in general it is rare for an event to be enacted more than once.[10] In *Wetherby*, however, Hare shares Resnais' penchant for repetitions and variations on repetitions.

Thus, Morgan's suicide, including the dialogue that immediately precedes it: Jean's comment on "the slow evenings" and her comment on Morgan's uninvited presence at the party as "Absurd! . . . Impossible!" is first shown near the beginning of the film. Shortly after that, it is reenacted by a policeman and policewoman, and then near the end of the film during a flashback to the landing scene between Jean and Morgan, it is repeated exactly as it occurred near the beginning. Here the repetition is interlaced with the end (the climax) of the Young Jean-Jim story, the death of Jim in Malaya. We see a young Malay passing a knife across Jim's throat and blood pouring from the wound, then the flashback to Morgan's suicide, then the shot of the knife seen going back and forth across Jim's throat and blood pouring from the wound is shown again. Also, while Jean and Morgan are on the landing as they go down to the floor, Jean brushes up against a nail on the skirting board and this produces a streak of blood on her leg.

On a purely visual level, the three time periods are connected here. All involve blood. The blood flows back and forth in time between the blood on the throat, the brains being blown out, and the blood on Jean's leg. The images are flashing before our eyes, but all of them are embedded in the fourth time period. Jean is explaining to Langdon how it happened that after leaving the party with Morgan and then returning she was wearing different clothes: it is because she snagged her stocking. We, the viewers and Langdon, are now able to fill in another space in the narrative. It is more difficult, however, to understand why the various time periods are brought together here through the haunting images of the spilling of blood. It is possible that Jean associates the terrifying experience with Morgan with the death of Jim, but surely it is unlikely that she would know the precise circumstances of Jim's death in Malaya: in a shack where he and an army chum were attempting to get in on a card game. No, it is surely here, above all, that audiences may sense the manipulative hand of the

director/writer, shuffling fragments like a man shuffling a deck of cards.

The meaning or lack of meaning is in the montage, in the reshuffling of the story, in the arrangement of fragments, the artful concatenation. Throughout we sense that Hare, like Jean, is deliberately concealing something. In his work on narrative, Genette calls this phenomenon *paralipsis*: "Here the narrative does not skip over a moment of time, as in the ellipsis, but it sidesteps a given element."[11] Jean's late revelation about the stocking makes it clear that indeed something or things have been left out, so some gaps may be temporary; but when we come to the end of the film we realize that other gaps are permanent: meaning is forever postponed or deferred; gaps lead to more gaps. Hare could have stitched his film together in any number of ways including no anachronies at all, a one-to-one correspondence between story (*histoire*) and narrative (*récit*); but even then, something would always be left out because of the enormous gap between the time period covered by the events and the film's running time. Although some of the questions that we have about why Morgan chooses Jean may have been answered, it is up to us to make sense of the writer/director's temporal reordering, and in particular the rapid concatenation of images invoking a terrifyingly bloody perpetual present.

One may suggest a thematic link between Jim's bloody death in Malaya and John Morgan's in Jean's home in that both may be triggered to some extent by Jean's silence, by her inability or refusal to express her true feelings. Jim's death might have been averted had Jean insisted that she did not want him to go to Malaya. At one point she explains to Marcia that with Jim she could not speak: "Because . . . because I read books I feel for some reason I'm not allowed to talk. For that reason there is always a gulf." Thus on the runway as Jim is about to leave, he gives her the chance to speak out: "If you want to stop me, you can," he says.

> *Young Jean*: No, I'll study. I've lots to do.
> *Jim*: Are you being true with me?

Young Jean: True? What does it mean?
 (Jim waits, serious.)
Jim: If you've anything to say, speak it now.
 (There are tears in her eyes. She shakes her head.)
Young Jean: Nothing.

About thirty years later on the landing, Morgan suspects that Jean is not expressing the true reason for bringing him upstairs. Perhaps Jean has never come to terms with the loss or her role in the loss of her young love, and although perhaps she finds some consolation in teaching (she clearly enjoys her job), her cheerfulness may indeed to a large extent be faked. Sensing Morgan's madness, she backs away from him on the landing, but the next day, with that obligatory British politeness and stiff upper lip, she invites him into her home for some tea. In the conversation that follows, beginning with the good old English stand-by, the weather, Jean begins to worry when she realizes that Morgan did not come to the party with any of the invited guests, but was a complete stranger walking in off the street; but all she can say is "Absurd! It's impossible!" Perhaps Morgan senses that even if Jean has been where he is, she's not going to talk about it; she is going to suppress it like she suppresses everything else.

Several scholars have commented on Hare's recurring interest in the British character, and indeed, it is not difficult to see Jean's failure of emotion, her reluctance or refusal to express feeling, as a comment on British reserve.[12] It is also possible to see then Prime Minister Thatcher as implicated here, for at the dinner party Stanley describes Thatcher as "Taking some terrible revenge. For something. Some deep damage . . . crimes behind the privet hedge." Indeed, the portrayal of the confused adolescent dropping out of school and of the gloomy streets of the urban wasteland through which Jean Travers wanders at night may be signs of Thatcher's seeming indifference toward certain social problems. Furthermore, the death of Jim (Jean's teenage love) in a shack in Malaya could be a comment on the injudiciousness of Britain's presence in that part of the world in the 1950s.

In order to privilege one of these scenarios and move to the larger theme, however, it is necessary to select a particular time period. Thus, I am suggesting that the subject of the film cannot be centered on any one time period: how could we decide, for example, on the relative importance of colonialism (the fifth time period) and Thatcherism (later time periods)? If we are to privilege anything, we should privilege the movement between the different time periods. Rather than representing a particular theme, it participates in a form of play which takes us, if you will, beyond thematicism, for play is not so much a subject of the film but rather a function of the film's very existence. Furthermore, it may be the movement between the different time periods which in its playfulness accounts both for the frustration and the exhilaration that viewers may experience.

Wetherby works, then, by a process of grafting one time period onto another, present onto past, past onto present, and so on. The film may be organized around gaps in the narrative, but which, we may ask, is the most important gap? We may be tempted to think of John Morgan, described by one character as "a central disfiguring blankness," as lying at the film's center; for near the beginning of the film, his action of inserting the revolver into his mouth and pulling the trigger in a sense triggers the rest of the film. I would be reluctant though to suggest that either a character or an event lies at the center of the film. Morgan's suicide certainly does not produce an end to speech, either in terms of silence or purpose. Our own discourse must inevitably fail to locate a real center, and we are left ultimately with subjects which are always decentered and deferred. Nevertheless, we may admire the artful use of montage and be haunted by the repeated bloody fragments which may be the filmmaker's idea of a joke—an intriguing but disquieting one.

Alain Resnais' films, particularly *L'année dernière à Marienbad*, have been criticized for appealing to "a crossword-puzzle-solving part of the mind" and viewers of *Wetherby* may be tempted to reproach Hare's film in the same way.[13] It is not easy to disentangle the

different time periods and would be impossible, I think, in a single viewing. Nevertheless, I suggest that the concatenation of fragments produces a striking emotional force, and at the same time, revitalizes filmmaking (and film viewing) by manifesting a vibrant playfulness that discourages viewers from being too hasty in centering their interpretations on any one subject. The last line of the film, then, "To all our escapes," seems singularly appropriate.

NOTES

[1] For a more extensive summary of the "renaissance" in the British film industry and Hare's placement in relation to other British filmmakers, see Joan Fitzpatrick Dean, *David Hare* (Boston: Twayne Publishers, 1990), 81-83.

[2] Quoted in Julian Petley, "Review," *Monthly Film Bulletin* 52 (March 1985), 72.

[3] See, for example, Jody Lee Oliva's *David Hare: Theatricalizing Politics* (Ann Arbor: UMI Research Press, 1990), although (as the title indicates) Oliva tries not to disassociate the politics from Hare's dramaturgical impulse.

[4] Quoted in Steve Lawson, "Hare Apparent: David Hare Interviewed by Steve Lawson," *Film Comment* 21 (Sept./Oct. 1985), 19.

[5] Gerard Genette, *Narrative Discourse* (Ithaca, NY: Cornell Univ. Press, 1980), 40. David Bordwell and other film theorists seem to prefer the terms *fabula* and *syuzhet*. See for example Bordwell's *Narration in the Fiction Film* (Madison: Univ. of Wisconsin Press, 1985).

[6] I am employing the term "montage" in the sense that it was originally used by Eisenstein. See Jacques Aumont, *Montage*

Eisenstein (Bloomington: Indiana Univ., Press, 1987), trans. L. Hildreth, C. Penley, and A. Ross.

[7]Genette's terms, *analepsis* and *prolepsis*, do not seem to me to improve on the more commonly used terms in film studies, flashback and flashforward.

[8]Genette, 48.

[9]In *Wetherby*, Jean is not the only character to flashback. Karen, for example, flashes back to her experiences with Morgan at the University of Essex.

[10]Bordwell, 79.

[11]Genette, 52.

[12]In a recent book on David Hare, Joan Fitzpatrick takes it for granted that Hare's primary subject is the British. See Fitzpatrick, ix.

[13]For the criticism of *L'année dernère à Marienbad* see Dwight MacDonald, "Review," *Esquire* (June 1962), 49.

6. REPERCUSSIONS OF THE CIVIL WAR
IN THE CANARY ISLANDS

Margarita M. Lezcano

LUIS LEÓN BARRETO BELONGS to a group of Canary Islands writers who gained prominence in the seventies. Some of the more important figures of this group are J.J. Armas Marcelo, Rafael Arozarena, Luis Alemany and Luis León Barreto himself. These young writers succeeded in reviving the somnolent literature of the islands. The authors of "the boom of the 'narraguanches'" as the movement is called, adopted the themes and concerns of the poets and prose writers who preceded them. These themes are isolation, the feeling of the sea, melancholy, solitude, a love for the islands' rugged nature, the feeling of insularity and the eagerness for cosmopolitanism. Martínez Cachero, a critic who has studied these writers, says:

> If we had to point out common characteristics that give the group a certain cohesion, they would be the following: a good portion of these novelists were university students; they had a strong desire to become professional writers and not merely curious amateurs; they renounced the use of picturesque details in their presentation of themes centering on customs and folklore in order to surpass the limited geo-

graphic space of the islands; and they experimented with new stylistic and structural forms.[1]

For these writers, literature was a catalyst, a merciless inquiry into the archipelago's past and present. For them, the islands were a microcosm of the world where, according to León Barreto, life "is more intense, more hermetic, more surreal and also more poetic."[2] This group of novelists wanted to investigate and analyze history, the socioeconomic reality of the islands and the collective and individual conscience of present day men.

At the end of the sixties, when many of them were university students, they began to rebel against the "status quo" of the Franco regime. They felt the need to break with the isolation in which Spain had been submerged for the previous twenty years and demonstrate their disagreement with the reactionary military dictatorship. For these young men the islands were a "torture chamber," and the dictatorship represented silence, injustice, oppression and fear. In short, man's inhumanity to man.

With Franco's death in 1975 and the end of the dictatorship, democracy was established. Freedom of the press was granted and the intellectuals of the Canary Islands aired the frustration and resentment which they felt for having been educated in an oppressive society. León Barreto wrote "we are the first of freedom's children, a pioneer generation which has received enough slaps in the face."[3]

León Barreto's *The Infinite War* (1985) is a fictitious historical account which attempts to reproduce reality by placing the evils of the past in their proper perspective while expounding upon the present. Alternating the historical episodes, which are veiled in irony, with the events of the Spanish Civil War, the author projects what is, in its most basic form, an ethical concern: the critique of the human character, the unending cruelty of man against man that is the "infinite war" that he is alluding to in the novel. History is seen with new eyes; the author wants to recreate it and to write a new version of the events of the past. William Dean, in his book *History Making History,* says as much:

"historical reality is created through the interpretations of historical material, that is, history makes history."[4]

To give veracity to his story, Barretto, who did not witness the Civil War, uses a device that has a long literary tradition. Imitating Cervantes, he says that he has received some "secret papers." In them, a Castilian doctor who practiced on Grand Canary Island during the Civil War relates what he saw and felt when faced with the tragic events. This character will henceforth be the fictitious narrator and a source of information. Being from mainland Spain, he is more objective in observing the customs and idiosyncrasies of the Canarians. In addition, he is a liberal and a scientist and he can therefore judge the events of the war dispassionately.

The narration unfolds on three levels: the present, the immediate past and the historical past, which do not maintain a chronological order. In order to give his narration authenticity the narrator describes in detail the places and circumstances in which each incident takes place, mentioning historical individuals together with fictitious characters, and pokes fun by imitating the rhetorical language used by the Falangists, the history books and the chronicles written on the conquest of the archipelago in the fifteenth and sixteenth centuries.

The present occurs when the doctor in 1941 writes his memoirs from a sanatorium in the Pyrenees where he is recovering from a depression. Two years have passed since the Civil War ended, and at the moment that he writes, he experiences the catharsis of his accumulated memories. He states: "I feel fine—because as I sketch out these lines—it's as if I were purifying myself. It is a sensation similar to confession or psychoanalysis."[5]

The immediate past deals with the brief period of the Second Republic and the beginning of the Civil War. He observes and critiques the incidents that are taking place before him. The narrator follows the steps of Francisco Franco, starting with his arrival in the Canary Islands, after the government had made him Captain General of the archipelago and Marocco because the authorities were not sure of his

loyalty towards the newly elected democratic government. This transfer was supposed to keep him away from the mainland and the political unrest.

While Franco was conspiring with the other generals, winding up the details for the coup d'etat, "a true spider web continued to spread among the participants in the plan"(44); meanwhile the government representatives in Madrid were trying to carry out the numerous reforms needed to bring the country out of the century-old marasmus into which it had been submerged by the monarchy. In addition, the new government was also trying to unite and please the parties on the left.

On the 18th of July, 1936, war was declared and the military dictatorship was established in the Canary Islands, meeting only a feeble resistance on the part of the legitimate provincial government. From this moment on the narrator relates events as they were happening: the repression, the detentions, raids, assassinations and disappearances of those known as "red" and "seditious," "informers and victims, officials and suspects turned up everywhere" (148). The rebel soldiers occupied the headquarters of the leftist parties, seized the list of affiliated persons, and with these in their hands they chose the people who were to be eliminated or imprisoned. The Republicans found themselves subjected to internments in jails and concentration camps, purges, interrogations, electric shocks, executions at dawn, and dropped into the holds of ships, from whose decks they would be thrown into the sea, and hurled into the famous Jinámar Chasm (120).

The terror was systematic and effective from the beginning in the Canary Islands, and from then on the archipelago would be a determined collaborator with Franco's regime. Regiments of so-called volunteers were sent to the battle fronts on the Peninsula. A few weeks after the military uprising, the life in the islands seemed to return to normal but the impact suffered by the Canary Islanders' psyche was deep and traumatic. The hopes that had been placed in the Republic faded away and the islanders once again withdrew into themselves,

lapsing into their previous mode of behavior which consisted of introversion and skepticism:

> The Islanders are so skeptical because after five centuries they are tired of big words. Perhaps their apparent indolence is a defensive attitude. Like their sad, sly humor, peculiar to people who are on guard and who to a certain degree have inherited the moody temperament of the aborigines (Guanches), who would just as soon reveal a fleeting euphoria as fall into depressed trances (157).

Depending on the position taken, the Spanish Civil War represented either the military fascism imported from Germany and Italy, having as its followers the royalists, the clergy and the bourgeoisie, or it represented the liberals, the intellectuals and the socialist proletariat. The conflict soon transcended the Spanish borders and became for the intellectuals of the world "an allegory in which the major social and political philosophies of the time were the chief antagonists."[6] Fascism threatened to "entomb forever the values of democracy and liberty, the entire legacy of a civilization built on tolerance and brotherhood" (86).

In the historical past León Barreto reinterprets history. The author abandons the hypothetical position of impartiality traditionally given to the historian, in order to cope with history from a revisionist perspective. He uses metaphor and myth to allude to a legendary past of the Canary Islands, and with a subtle and ironic language, he succeeds in making the history and the legend less sacrosanct. Classical literature called the islands "Hesperides," "Atlantis," and "Blessed," and on them, according to the bards:

> The noblest of the sky had been set aside
> the purest and most pleasant air
> the least ferocious and most tranquil seas and the most
> fertile plots of earth,
> the greenest and mildest of forests
> the freshest and most gentle of flowers (150).

Departing from an idealized and poetic vision, in imitation of the dirges and chronicles of the islands's conquest of the fifteenth and sixteenth centuries, the author slips into a bitter criticism of the conquest and colonization. He recreates history, ignoring chronological time, trying to present a deeper and more truthful version of history in order to arrive at the bottom of the fundamental facts and to clarify the causes which brought forth the precarious development of the economy and the formation of the islanders' character, which is "the predisposition to drowsiness and to persistent melancholy" (15). These are, in effect, the dominant characteristics of a people who are "pacific and tolerant, re-signed and placid" (53).

Thus, León Barreto reconciles himself with what Borges maintains when he says that what interests him more is not so much what is exact but what is symbolically true.[7] Based on the historical facts of the Canary Islands, the author dissects and critiques the archipelago's perennial misfortunes: the near extermination of the Guanches (the native inhabitants of the islands); the plunder of the land and its redistribution to captains and governors; the colonial exploitation; the emigration to Latin America forced on the people by the monarchy in the seventeenth and eighteenth centuries; the scarcity and misuse of the water and land and the consequences of tourism.

The Infinite War is a satire that seeks to reform. It is a critical and lucid examination of history, insofar as it gives us a clear picture of what happens when human beings interact with each other and the effects of that interaction: violence, plunder and the subjugation of the weak. It is a cruel and perspicacious study of the character of the human race and a skeptical, disillusioned, and biting vision of society and of the future of man and woman. The Spanish Civil War in this novel has become again a symbol of all wars and it "did not fail to carry the seed of all the egotism and depredation of the human race, the infinite war of man against man" (160).

70

NOTES

[1]José Martinez Cachero, *Historia de la novela española entre 1936 y 1975* (Madrid: Castalia, 1976), 273. Quotes translated by the author of this paper.

[2]Luis León Barreto, letter to the author, August 1986. Translated by the author of this paper.

[3]León Barreto, letter.

[4]William Dean, *History Making History* (Albany: Univ. of New York Press, 1988), 9.

[5]Luis León Barreto, *The Infinite War* (Barcelona: Planeta, 1985), 135. Subsequent quotes are identified by page references to this edition. All quotes translated by the author of this paper.

[6]Frederick R. Benson, *Writers in Arms* (New York: New York Univ. Press, 1967), 5.

[7]Miguel García Posada, "El libro de la semana: *Noticias del Imperio*," *ABC*, October 24, 1987. Translated by the author of this paper.

7. CINEMA WITH A FUTURE: THE DEVELOPMENT OF FILM IN QUEBEC AS AN AUTHENTIC EXPRESSION OF QUÉBECOIS CULTURE

Philip Reines

DURING THE LATE 1980S, after years of false starts and failed attempts, Canadian cinema, both Anglophone and Francophone, evolved into an internationally respected and multi-faceted art form, representative of the multicultural and bilingual entity that is Canada. Especially notable is the development and emergence of films not only reflective of national recognition, but also of world-class sophistication. That this status was the result of decades' long struggle for a genuine indigenous cinema against powerful entrenched obstacles, both within and without the country, is a matter of historical fact.

Unlike the centralized and corporate controlled commercial cinema in the United States, the film industry in Canada, both public and private sectors, evolved from several diverse cultural and ethnic areas as different from each other as it is possible to be, in so vast a geographical expanse. This regional diversity was instrumental in setting the tone for Canadian film makers from 1900 to the present, to attempt to cap-

ture the extant diverse cultural milieu of the country. Of major signifi-
cance was the founding of the National Film Board in Ottawa by the
government in 1939, under the leadership of noted Scottish documen-
tary film producer John Grierson.[1] It is not within the scope of this pa-
per to discuss the influence of the American film industry in Canada
except to note that despite Hollywood's powerful influence on feature
films and theatres in Canada during the first fifty years of this century,
the indigenous fledgling film industry somehow managed to survive
and, in some instances, actually flourish for short periods of time. But
not until the establishment of the NFB did a national focus appear for
talented cinema artists to come together for the purpose of using film to
"Show Canada To Canadians and Canada To The World." Thus, from
1939 on, a culturally coherent structural beginning was successfully
implemented and the artistic seed planted. The focus of this paper will
be the explorative overview of the development of contemporary
Quebec cinema.[2]

The beginning of contemporary cinema in Quebec has its roots in
the thirty-odd years dating from the 1920s through the 1950s, when
numerous efforts by a number of independent producers to create a
Francophone feature film industry was attempted. Such enterprising
cinéastes as Maurice Proulx, Albert Tessier, Joseph A. Deséve, René
DeLacroix, Denis Gillson, Raymond Garceau, Jeann-Yves Bigras
(among others), and a number of film companies led by Quebec
Productions and Les Productions Rénaissance met with some small but
sporadic success. Although artistically sound, these efforts failed to
sustain a commercially productive momentum necessary for economic
survival. In 1951, Quebec Production Corporation folded after complet-
ing René DeLacroix's *Le Rossignol et Les Cloches*. By 1953 other
companies discontinued operations, but not before the film of René
DeLacroix's and Gratien Gélinas *Tit Coq* ironically had won the Grand
Prizes at that year's Canadian Film Awards.[3]

However, in 1955, during the post-war expansion of the NFB into
television, a successful attempt to begin French language production

was achieved with two landmark series. The first of these, *Passe-Partout* (1955-1957), stressed the visual and cultural authenticity of French Canadian traditional life in Quebec Province, and in doing so, established many of the visual and thematic parameters for artistic expression. *Passe-Partout* utilized a combination of dramatic narrative and visual documentary styles to illustrate its themes. *Panoramique,* (1957-1959), the second Francophone format, presented a series of thirty-minute dramas. These television productions are significant, not only as seminal cultural breakthroughs in a society heavily dominated by the English language and tradition, but also as legitimate artistic devices by which such emerging young cinematic artists as Claude Jutra, Georges Dufaux, Gilles Groulx, Michél Brault, and Bérnard Devlin, among others, were able to hone their skills and explore the intrinsic nature of their own Francophone culture.[4]

In 1956, the NFB moved its studio to Montreal, and during the next ten years, further consolidated and refined the activities of its new French production unit. Through the creative efforts of Fernand Dansereau, Louis Portugais, Bérnard Devlin, Léonard Forest, Gilles Groulx, Gilles Carle, Arthur Lamothe, Pierre Patry, Claude Fournier, Clément Perron, Pierre Brault, and Claude Jutra, among others, the late 1950s and 1960s saw a veritable artistic explosion of québecois cinematic productions emanating not only from the NFB but also from independent sources. All this activity conspired to evolve a "new" contemporary québecois "point of view" in films of the period. Such films displayed with visual and sound verity the cultural and religious traditions, conflicts and spirituality of an oppressed and depressed French-Canadian population caught in a crisis of ethnic identity. Typical of this period was Claude Jutra's *A Tout Prendre/The Way It Goes* (1963). This film, produced independently for $60,000, won wide national and international recognition and illustrated that dramatic French language feature films made for commercial distribution could be produced successfully in Quebec. Other filmmakers soon followed Jutra's lead and a "new" feature-length Francophone Quebec cinema evolved,

independent from conservative Catholic Church authority and government restriction, secular in theme and social concerns. The cinema industry of the québecois was established.[5]

In 1961, Quebec cinéaste Michél Brault, working in France, produced films in which the technique of direct cinema, an intimate cinematic visual style from France, was utilized. This technique was enthusiastically accepted by many Quebec filmmakers as an instrument indispensable to the artistic needs of québecois cinema. Both Michél Brault and Pierre Perrault artfully displayed this technique in *Pour La Suite du Monde/Moontrap* (1963). This film placed visual and thematic emphasis on the importance of "Tradition as an expression of the collective life and will of a people."[6] The film won critical success for its frank and intimate probing into the complexities of ethnic life. As film critic Peter Morris states: "It represented a major development in direct cinema away from simple observation to more immediate participation and a greater emphasis on the words of the people portrayed. . . ."[7]

It must also be noted that during the 1950s the Bureau de Film du Quebec was established. The Quebec filmmakers founded as well the Connaisance du Film in 1963, which would become the Cinemathéque Québecoise in 1971.[8] In 1964, L'Association des Cinéastes du Quebec presented a report to the governments of Quebec and Canada which detailed the necessity for opportunity that allowed the English-language Canadian cinema, and French language Quebec cinema to grow and flourish within the Province. It also requested support from the government to aid in developing regional efforts in filmmaking. This report established the tradition of political lobbying by various cinema groups for financial and cultural support within Quebec Province, which continues to the present.

Throughout the 1960s, the period known as "The Quiet Revolution" (1960-68) took place in which the Francophone of Quebec began a movement for ethnic recognition and political (if not ideological) self-determination, independent from the dominant Anglo-Canadian national majority. Acting in more militant fashion, and less as

a people dominated by empire and separated from their European French roots, the Quebec Francophones—intellectuals, cinéastes, artists, and the political elite—began a new examination of québecois culture. Leading this retrospective was the evolving Quebec cinema. In many of the films produced in Quebec during the years of "The Quiet Revolution," no aspect of traditional values, attitudes and struggles was ignored: individual discontent, group conflict, urban versus rural values, the changing roles of the Church, the economy, sex and love, and, of course, in the midst of it all, the "Dramatis personae", i.e., the French Canadian emerging as québecois. A "new-old" identity was refurbished for the emerging present and promised a more fulfilling and self-rewarding future. The inevitable result of this looking inward was the demand for political separatism and self-determination for Quebec Province.[9]

Beginning in the 1960s and continuing throughout the 1980s, the evolution and expansion of the Quebec cinema progressed artistically from a provincial expression of ethnic frustration into an articulate, cinematically sophisticated and richly talented, maturing industry capable of producing films of world-class stature. Commensurate with these films were the highly individualistic statements made by a growing number of Quebec auteurs attempting to define their aesthetic parameters in dealing with the lives and environmental considerations of the québecois in Canada.

The self-searching quality of the Quebec Francophone in personal and collective crises is evident through diverse styles in landmark films, both narrative and documentary, such as: Gilles Groulx's *Golden Gloves*, 1961; Michél Brault and Claude Jutra's *La Lutte/Wrestling*, 1961; Clement Perron's *Jour Apres Jour/Day After Day*, 1962; Arthur LaMothe's documentary *Bucherons de la Manouane/Manouan River Lumberjacks*, 1962; Paul Almond's *Isable*, 1963; Pierre Perrault's *Pour La Suite du Monde/Moon Trap*, 1963; Gilles Groulx's *La Chat Dans Le Sac/The Cat in the Bag*, 1964; Jean Pierre LeFebvre's *Il Ne Faut Pas Mourier Pour Ca/Don't Let It Kill You*, 1968; Paul Almond's *L'Acte du*

77

Coeur/Act Of The Heart 1970; Gilles Carle's *La Vraie Nature de Bérnadette/The True Nature of Bérnadette*, 1971; Claude Jutra's acclaimed masterpiece *Mon Oncle Antoine/My Uncle Antoine*, 1971; Pierre Perrault's *L'Acadie L'Acadie/Acadia*, 1971; Claude Jutra's *Kamouraska*, 1973; Jean Claude Lord's *Bingo*, 1974; Michél Brault's *Les Ordres/The Orders*, 1974; Jean Pierre LeFebvre's *L'Amour Blesse/The Blessed Love*, 1975; Gilles Carle's *L'Ange et La Femme/The Angel and the Woman*, 1977; Jean Beaudin's *J. A. Martin Photographe/J. A. Martin Photographer*, 1977; Gilles Carle's *Les Plouffe/The Plouff Family*, 1980; Francis Mankiewicz's *Les Bons Débarras/Good Riddance*, 1980; Denys Arcand's *Le Confort et L'Indifférence*, 1981; Lea Pool's *La Femme de L'hotel/Woman of the Hotel*, 1984; Justine Heroux's *Le Matou/The Tom Cat*, 1986; and Denys Arcand's *Le Déclin de L'Empire Américain/The Decline of the American Empire*, 1986; *Jésus de Montréal/Jesus of Montreal*, 1989; and Bruce Beresford's *Black Robe*, 1991. These films are only a small select listing of the creative outpouring of the contemporary Quebec cinema.[10]

In any discussion of Quebec cinema, the place of the auteur principle is important since so many of the films produced reflect it. This philosophy stresses that the personal cinematic style of an individual director is considered to be the most vital aspect in determining the artistic quality of his/her cinematic work. The auteur philosophy was first illustrated during the New Wave Movement in France in the 1950s. Critics Andre Bazin and Alexandre Astruc, among others, encouraged acceptance of this philosophy. In 1954, director Francois Truffaut published his article "Une Certaine Tendance du cinema Francais," in the influential film journal *Cahiers du cinema*. His article stressed that film should serve as the ideal artistic medium for personal artistic expression, and that the visual language of cinematic technique is as artistically sound as the written language of literature. The acceptance of this concept by Quebec cinéastes as one of the most artistic visible characteristics of Quebec cinema is a fact.[11]

The impact and acceptance of the auteur principle, together with the intimate visual style of direct cinema, provided Quebec cinéastes with major visual tools for capturing the vitality, reality and intimacy of life in Francophone Quebec. These and other major aspects of the New Wave Movement took root and together with the decentralized nature of the commercial cinema in Canada, shaped the basic structure and identity of Francophone Quebec cinema as it approached the 1980s.[12]

The decade of the 1980s have brought a "new sense" of maturity and sophistication to *all* aspects of Quebec cinema in particular and to Canadian film in general. The *best* of English and French-language Canadian films reflect a renewed sense of nationwide artistry and purpose. Nowhere is this better illustrated than in the emergence of the *entire* Canadian film industry into world-class prominence.

The development of film in *all* of Canada is guided both by the paternalistic hand of government-subsidy grants and loans and an *increased* financial capability in the independent and private commercial sector. Both arenas recognize the marketability of films produced in Canada, as well as the fact that Canadian geography provides some of the best "location shoots" in the world. This, and the availability of experienced crews and state-of-the-art equipment, have made Canada most attractive to the international film industry as a place to work and produce films.

Notwithstanding this increasing recognition, the distribution problem of Canadian films in Canada during 1987 has not appreciably changed since 1985 but is improving.[13] The major problem of course is that the U.S.-controlled major theatre chains in Canada still account for 92-93% of the total English language film revenues and 80% of the French box office in Canada. As a result, over the years, only a small percentage of Canadian audiences have had access to their own cinema. However, this is changing rapidly.

Most significant for cinema in Quebec is the passage of the *Quebec Cinema Act* in 1983, in effect since September 1988. Sections 104-105 "Specifically prohibit independent foreign and Canadian distributors

from doing business in Quebec if they are not based in the Province or fail to meet specific legal qualification criteria."[14] Indeed, Quebec has moved forward importantly to protect its cinema and ensure an adequate distribution of the Quebec product within the Province. The original intent of the Quebec Cinema Act was, of course, to encourage and protect the indigenous industry. By 1987, the films made in Quebec accounted for 10% of the annual film exhibition total within the Province, a figure that is steadily improving.[15]

However, there are still formidable obstacles to overcome and challenges to be met if Quebec, or québecois cinema, is to continue and flourish. The first challenge is: (1) to continue to use film as a *record* for cultural preservation in order to maintain ethnic authenticity and artistic roots; (2) to continue cinematic probing into the "human condition" and the personal and cultural concerns it expresses; (3) to utilize cinema as an integrative tool for illustrating essential humanistic universal values which reach *beyond* cultural and language differences; (4) to maintain and encourage diverse forms of artistic concepts and styles that are responsible for much of Quebec cinema's successes; (5) to resist any attempt to shape the industry into a "centralized national corporate entity" and away from regional diversity; and (6) to continue the mandate of the National Film Board in its broadest possible context and show québecois culture to Canada and to the world.

One final point should be made. It is essential for Quebec cinema to accept and recognize its own singular identity and not attempt to emulate Hollywood or what it may deem a more favorable foreign film industry image, in order to curry more favorable markets for distribution and exhibition of its films. The Canadian government and the film industry should continue their support to ensure that Canadian citizens have the opportunity to view their provincial and national product in theatres across Canada. Until recently, inadequate distribution outlets within Canada prevented many of Canada's finest films from being shown to audiences eager to see them. Only during the last nine years has this problem gained serious attention and concern. It

is simply no longer possible for critical opinion within Canada and world-wide to ignore the remarkable cinematic achievements and growing artistry of Quebec cinema. But this is certain: the rich cultural message of Quebec cinema must be seen and cherished by those it serves if it is to endure.

NOTES

[1]Peter Morris, *The Film Companion* (Toronto: Irwin, 1984), 135-136.

[2]Sally Bochner, *All About Us* (Montreal: NFB, 1982), 3-18, and Piers Handling, (Ed.) *Self Portrait* (Toronto: Mutual, 1985), 42-89.

[3]Morris, 297.

[4]Morris, 228.

[5]Seth Feldman (Ed.) *Take Two: A Tribute Film in Canada* (Toronto: Irwin, 1984), 21-23, and Morris, 3, and Handling, (Ed.) 96-99.

[6]Morris, 243-244, 42. A technique closely resembling direct cinema was developed by Canadian filmmakers working at the NFB during the decade of the 1940's. As such it became an important aspect of the direct cinema technique as it evolved in Canadian Film.

[7]Morris.

[8]Pierre Véronneau (Ed.) *Self Portrait* (Ottawa: Canadian Film Institute), 190.

[9]Feldman, (Ed) 112-182.

[10]Handling, (Ed.) and Morris.

[11]James Monaco, *The New Wave* (New York, Oxford, 1977), 3-12. In the United States, film critic Andrew Sarris is one of the major advocates of the auteur principle of "personal authorship" in cinema.

[12]Handling, (Ed.) 77-93.

[13]Connie Tadros. (Ed.) *Cinema Canada* (Montreal, 1973 through 1988). Canada's foremost cinema periodical containing numerous

articles, reviews, essays on Canadian and Quebec film. Vols. 1 through 16. No. 146, November 1987, 31.

[14]No. 157, November 1988, 36.

[15]No. 146, November 1987, 31.

8. THE CRACK IN THE FACADE: SOCIAL AFTERSHOCKS OF MEXICO'S 1985 EARTHQUAKE

Mary Tyler

IN MEXICO CITY'S NATIONAL Museum of Anthropology in the summer of 1988, our tour guide Mario pauses before the great Sun Stone. More earnestly than is usual in his line of work, he points out, one by one, the carved glyphs referring to the ancient Aztec prophecy of five great cycles of history. At the end of the first, so the doctrine goes, the earth was destroyed by falling sky, the second, by storms, the third, by flames, the fourth, by flood. The fifth cycle, which includes our own time, is to meet its doom in a cataclysmic earthquake.[1]

Intrigued by the intensity of Mario's description of the earthquake prophecy, I later ask him if he remembers what he was doing at the moment of the earthquake on September 19, 1985, three years before. He does indeed remember. His Grey Line tour bus pulled up in front of the first hotel on his route just before 7:20 that morning, and he headed toward the lobby to pick up his passengers for the all-day tour of the city. Suddenly the tremor began. At the end of what seemed an interminable shaking, the ruins of the hotel he had been about to enter lay collapsed in a heap before him.

Mario and his driver immediately fell to the work of clearing the rubble with their bare hands, tortured by the agonizing screams of trapped hotel guests and staff. All day and into the night they dug out corpses and survivors, their hands bleeding for lack of gloves or tools. When Mario was completely exhausted, he went home to bed, but he could not sleep for sobbing. He had not thought he could cry so many tears, he told me. For days he worked as long as he could, then went home to cry, then back to the ruins to work. He could not stay away knowing that so many were still trapped.

Mario's story is a real life corroboration of the moving accounts of the earthquake compiled by two of Mexico's most noted chroniclers, Carlos Monsiváis and Elena Poniatowska. Nearly half of Monsiváis's 1987 essay collection, *Entrada libre: Crónicas de la sociedad que se organiza*, recreates the events of the earthquake in much the same way that the 1968 government massacre of students was recreated in his testimonial narrative, *La noche de Tlatelolco* (1971).

The form of the testimonial narrative has long been popular in Mexico, especially since the publication of Oscar Lewis's *Children of Sanchez* in 1961. Indeed, as Mary Ellen Kiddle has pointed out, the form has its roots in the first novel of the Hispanic New World, *El periquillo sarniento* by José Joaquin Fernández de Lizardi, himself a journalist.[2] Like Fernández de Lizardi and countless other predecessors, contemporary Mexican writers have often turned to a form that combines journalism with literature in order to reach a larger audience, circumvent government censorship, and call attention to needed social reforms.[3]

The theme running through the earthquake chronicles of both Monsiváis and Poniatowska is that of the spontaneous growth of democratic social organization to help people get desperately needed services that were not forthcoming from inept or venal government officials. The disaster was so overwhelming that tens of thousands of city residents, even those living in areas unaffected by the tremors, mobilized to fill what amounted to a political vacuum. This theme is echoed in a re-

cent remark by Armando Ramirez, a well-known novelist who lives in Tepito, one of the central city neighborhoods hardest hit by the quake. The events of September 1985, Ramirez told me in 1990, showed the people that they could do without the government.[4]

Although both Monsiváis and Poniatowska include anecdotes of individual officials who are exceptions to the rule, in general the Mexican government is depicted as bumbling and counterproductive. Soldiers charged with cordoning off the ruins, for example, again and again brandish machine guns to chase off would-be rescuers, even within earshot of the cries of trapped victims. President Miguel de la Madrid Hurtado arouses scorn and ridicule when he proudly refuses outside aid, claiming to be able to handle a crisis that is clearly beyond Mexico's resources. He undercuts his popular support by stubbornly underestimating the extent of the tragedy, and he is perceived as cold and unfeeling toward the suffering of the victims. Defying the government's exhortation to stay at home and remain calm, volunteers stream from all parts of the city to help. By the time the government recognizes that it cannot cope with the disaster without the volunteer corps, the volunteers themselves have learned that they can indeed cope without the government.

In line with their theme of democratization, both Monsiváis and Poniatowska highlight anecdotes of the sudden politicization of ordinary people. The most outstanding examples occur in connection with the formation of the seamstresses' union named after the fateful date of the earthquake, September 19th, but other "awakenings" are legion. The chroniclers present the voices of the "temblor" as those of people who will never again stand for the old ways. Monsiváis writes that neither political denunciations nor media exposes nor eyewitness testimony had managed to accomplish what the earthquake accomplished in an instant: "desmitificar de raiz y hacer visible la sordidez antes considerada 'lo natural.'"[5]

The second essay in Monsiváis's *Entrada libre,* immediately after "Los dias del terremoto," is "San Juanico: los hechos, las interpreta-

ciones, las mitologias," an account he had written previously of the massive gas explosions that in November 1984 flattened the poor Mexico City barrio known as San Juanico, killing more than 500 people. In twenty years, the dense population of San Juanico had mushroomed in the once empty fields around two huge Pemex storage tanks.[6] In spite of warnings and criticism, the government had done nothing to avert the inevitable and horrible explosion of aging tanks in the midst of hundreds of sleeping families. The San Juanico explosions and the downtown earthquake the following year are linked by their proximity in time and space and by their similar social effects, especially as those have been interpreted by Monsiváis. The politicizing effects of both the explosions and the tremors, Monsiváis implies, lay in their sudden, traumatic revelation of the total corruption of governmental authority. The human tragedy of both disasters was immeasurably heightened by previous official dereliction of duty. In both cases, the interests of the rich and the propertied had long overridden the safety of ordinary people who had to live and work in the midst of the "modernization" of a developing country, but when the inevitable occurred, the government preferred to view it as a terribly unfortunate "accident," a word that Monsiváis repeats with mounting scorn in his account of San Juanico.

Likewise, just two weeks after the earthquake, *Newsweek* remarked on the significance of "splayed concrete and metal beside relatively unscathed structures," implying that Mexico City's strict 1977 building code had been regularly sidestepped. The quake left intact centuries-old buildings while destroying nearby modern structures. Ironically, the greatest damage was sustained by buildings owned by the government.[7] Both Monsiváis and Poniatowska take great pains to include testimony concerning the long history of neglect that had made of apartment complexes, factories, and hospitals little more than death traps. At one point, for example, Poniatowska highlights an informant's remark that her family wasn't killed by the earthquake but rather by the fraud and the corruption harbored by the government.[8]

Monsiváis places the earthquake in the context of a series of recent developments that have, together, revealed the reality of Mexican society to its members in much the same way that the Mexican Revolution, in the words of Octavio Paz's Nobel lecture, "unmasked what was hidden."[9] In the latter half of the 1980s, Mexicans are clearly interpreting their reality differently than before. The surprising results of the presidential elections of 1988, for example, in which the dominance of the Partido Revolucionario Institucional (PRI) was seriously questioned for the first time in over six decades, constitutes one of myriads of signs of important social shifts.

The cooperative efforts of thousands of volunteers immediately after the earthquake is taken by both Monsiváis and Poniatowska to indicate a solidarity movement with definite political overtones. Doubtless, however, clarification of a common interest implies a corresponding clarification of a common enmity. In his treatment of "la mitologia" surrounding the San Juanico disaster, Monsiváis delves into a level of deeply felt social rancor that has rarely made its way into print in Mexico. Less than two weeks after the tragedy, says Monsiváis, there suddenly appeared an epidemic of cruel San Juanico jokes, a subgenre of what he calls "humor naco."[10] The word "naco" is, he explains, an expression of both race and class prejudice on the part of those who consider themselves "criollo," that is, part of the modernized establishment. "Naco" humor makes sport of the marginalized masses whose greatest sin, Monsiváis writes, is that they bear no resemblance whatsoever to Robert Redford.

The San Juanico disaster would be tragic, says one wealthy lady, if it were to occur in the comfortable neighborhood of Las Lomas. Monsiváis explains that what makes it comic instead is the laughable physical appearance of the victims, so similar to the perennial comic figures of the typical poor Mexican popularized by Cantinflas, Resortes, Mantequilla, David Silva, and Héctor Suárez. As long as there is no danger of explosions in one's own neighborhood, horror can be quickly replaced by humorous digs at the notorious passivity, igno-

rance, and bad taste imputed to the victims. Since, as Monsiváis points out, there were no Pemex gasoline storage tanks in Pedregal, Coyoacan, or Colonia del Valle, those who were well enough off to live in those neighborhoods, or who expected to become so, could safely indulge in cracks like, "In San Juanico they don't serve 'tacos al carbón.' They serve 'nacos al carbón'!"[11]

By contrast, the tremendous spontaneous organization of youthful rescuers within hours after the earthquake, and the staggering courage of human "moles" who burrowed under precariously balanced ruins to rescue strangers, elicits from both Monsiváis and Poniatowska an unmistakably patriotic interpretation of events. The earthquake struck both rich and poor sections of the central city, suddenly victimizing Mexicans of all classes whom other Mexicans sprang to rescue even at great risk to their own lives. The ugly "naco" jokes of 1984 obviously did not apply in 1985. Instead, popular scorn switched from the "naco" marginalized by poverty and ignorance to the government functionary, marginalized in his turn by his insulation from the lives of ordinary Mexicans.

The word "naco" is undergoing an interesting transformation from a racial and class pejorative to a symbol of the emerging social reality. The most striking use of this previously disreputable word is that of José Agustin Ortiz Pinchetti in a book that was featured in the show window of nearly every major downtown Mexico City bookseller in August 1990: *La democracia que viene: Ejercicios de imaginación politica.* In Ortiz Pinchetti's contribution to the current flood of speculative scenarios concerning Mexico's future, the infamous word is projected into the next century, when it has come to designate Mexico's dominant social and cultural group. A character speaking in the year 2029 explains that the insulting pejorative "naco" evolved into a respectable term some time after the year 2000, when, he says, Mexicans became aware of the true racial and cultural composition of Mexico. These "nacos," it seems, come to represent in the twenty-first century human resources of extraordinary energy and ingenuity. Thanks to their

enormous potential for development, they are able to overcome the powerful oppression of the previously dominant class, the "criollos." "Naco" values, in this future Mexico, are reflected in a capitalism of the poor, characterized not by the Protestant ethic but rather by a strong sentiment of solidarity.[12]

The current Mexican President Carlos Salinas plays a pivotal role in this emerging mythology. Salinas, of course, was not prominent in the events recounted in Monsiváis's and Poniatowska's chronicles. The word "solidarity," however, appears frequently in the mouths of various of their informants, and became a more and more important concept during and after the critical 1988 presidential campaign and election. Cuauhtémoc Cárdenas, of whom Monsiváis in particular was an ardent supporter, was very nearly successful in replacing the perennial ruling party PRI with a leftist coalition organized around his breakaway PRI faction. After a narrow and suspect victory, however, the new PRI president was by the summer of 1990 spearheading a massive political and public relations program known by the name "Solidaridad" in an obvious and earnest attempt to coopt the populist stirrings among his electorate.

By the kickoff week of the campaign in early August, workers everywhere sported bright new white nylon windbreakers with the "Solidaridad" logo in Mexico's national colors of red, white and green. The government television channel showed President Salinas every few minutes, here opening a sewer, there dedicating new housing for the still-homeless victims of the earthquake, somewhere else being kissed by an old Indian woman in tearful gratitude for some political or legal favor. In between these short spots, longer programs showed endless discussion of the true meaning of "solidaridad." A defiantly denim-clad Carlos Monsiváis himself was interviewed in conjunction with one conference of sombre regional politicians. The media blitz had so thoroughly commandeered the word that when it came up in conversation with a young Mexico City couple, they hastened to assure me that when they said "solidaridad," they didn't mean *that* "solidaridad," referring to

the word emblazoned on a passerby's jacket. Propaganda for this national campaign has become so pervasive that each of the issues of the highbrow journal *Vuelta* has for several months carried the familiar tricolor "Solidaridad" logo on a full page ad for the national lottery featuring two smiling farmers and their new Massey Ferguson tractor. "For them and for Mexico . . . Let's give each other a hand," the reader is exhorted.

Clearly, the earthquake chroniclers see in the popular response to the 1985 disaster an important shift, replacing the passivity long thought to characterize the Mexican masses with a new surge of cooperative action. The Salinas administration seems to have tacitly granted credibility to the chroniclers' interpretation, struggling mightily to coopt a burgeoning popular groundswell of self-determination that had caught the previous administration by surprise in the wake of the earthquake. In Ortiz Pinchetti's scenario, Carlos Salinas is routinely referred to as the last "tlatoani," a name that unlike "presidente" evokes the continuity of the monolithic PRI with monolithic Aztec rule. Salinas turns out to be, from the twenty-first century perspective of Ortiz Pinchetti's narrator, the great president of the transition. His successor in 1994, unnamed of course by the narrator, is the first democratic president in the history of Mexico.[13]

Sympathetic observers of Mexico's tribulations can certainly understand the fervent hope many Mexicans must hold, not only that democracy will one day truly come, but also that the transition will be smooth. It is this hope that lies behind Octavio Paz's repeated declarations of faith in the efficacy of critical opposition. It lies behind most of the published speculative scenarios, like that of Ortiz Pinchetti, in which future developments will peacefully ameliorate the massive poverty and injustice that now afflict Mexico. It lies also behind Monsiváis's and Poniatowska's perceptions in their chronicles of what might be called "democratization by disaster."

Ironically, however, the real-life Carlos Salinas seems to be using his power as "tlatoani" not to effect an orderly transition to greater

democracy but rather to forge ties with the loyal rightist opposition Partido de Acción Nacional (PAN), effectively cutting off the party of Cuauhtémoc Cárdenas and bringing about a new conservative order.[14] Salinas is apparently dedicating his considerable talent and energy to subduing populist demands by offering instead an economic miracle that David Goldman of *Forbes* gleefully named "Salinastroika" and hailed last summer as "a revolution you can invest in." More ironically yet, he may even have employed the chroniclers' own myth of the rise of democratization and solidarity as a tool for achieving the aims of his administration.

Monsiváis and Poniatowska saw in the 1985 Mexico City earthquake the spontaneous generation of democratic life among their people. Understandably, they longed to see a new Mexico, and a new Mexican, rising from the city's rubble. Perhaps they were expressing one aspect of the perversely reassuring fatalism of Aztec cosmology—an unacknowledged expectation that problems will always be solved, or at least made irrelevant, by telluric cataclysm. This particular cataclysm did indeed crack the forbidding monolithic facade of Mexico's hierarchy. Time alone will tell what that will mean for the generation that lived through it. *Nada, nadie* ends with this witness's reflection:

> Y me pregunto: si el temblor marcó tanto a los mexicanos,
> si invadió tanto sus vidas, sus recuerdos, sus mentes, si los
> sacudió tanto y si a cada rato de una forma u otra resurge.
> çcuál será la marca que deje?[15]

NOTES

[1]This prophecy is described also by Eric R. Wolf in *Sons of the Shaking Earth* (Chicago: University of Chicago Press, 1959) 1.

SOCIAL AND POLITICAL CHANGE IN LITERATURE AND FILM

[2]Mary Ellen Kiddle, "The Non-fiction Novel or *Novela testimonial* in Contemporary Mexican Literature" (Diss. Brown University, 1984) 74.

[3]Kiddle, 88.

[4]Armando Ramirez, Personal interview, Mexico City, 4 Aug 1990.

[5]Carlos Monsiváis, *Entrada libre: Crónicas de la sociedad que se organiza* (Mexico, D.F.: Era, 1987) 106. Translation: "radically demythologizing and making visible the sordidness that was previously considered 'natural.'"

[6]Harry Anderson, et. al. "Mexico: The Killer Quake." *Newsweek* 106:14 (30 Sept 1985) 19.

[7]Anderson, 30 Sept 1985.

[8]Elena Poniatowska, *Nada, nadie: Las voces del tremblor* (Mexico, D.F.: Era, 1988) 83.

[9]Octavio Paz, "The Nobel Lecture," *The New Republic* 204: 1, 2 (7 & 14 Jan 1991) 36.

[10]Monsiváis, 144-147.

[11]Monsiváis, 148.

[12]José Agustin Ortiz Pinchetti, *La democracia que viene: Ejercicios de imaginación política* (Mexico, D.F.: Grijalbo, 1990) 24-5.

[13]Ortiz Pinchetti, 53.

[14]David Goldman, "A Revolution You Can Invest In," *Forbes Magazine* 146:1 (9 July 1990) 49.

[15]Poniatowska, 310. Translation: "And I ask myself: if the quake so marked the Mexicans, if it so invaded their lives, their memories, their minds, if it so shook them and if it resurges every so often in one way or another, what will be the mark that it leaves?"

9. FICTION INTO FILM: "IS DYING HARD, DADDY?" HEMINGWAY'S "INDIAN CAMP"

H. R. Stoneback

THIS IS A DIFFICULT, IMPROBABLE, if not impossible task; to discuss Hemingway's "Indian Camp," widely acknowledged to be one of the great short stories of the twentieth century; to discuss and to view a recent award-winning film based on that story, Brian Edgar's "Indian Camp"; and to do all of this within the space allotted here. Moreover, the difficulty is compounded—it seems a good policy to declare bias at the outset—by the fact that my fundamental perspective is that of a Hemingway scholar, something of a purist when it comes to Hemingway's texts. Add to this the fact that I was involved as a consultant in the making of the film of "Indian Camp." Then the final difficulty involves the scene of the crime: i.e., this mission is to be accomplished at a major national conference on film, a setting in which I feel a certain humility, where I am acutely aware that I have never before spoken one professional word about film, that as an old-line man of the written word my greatest sins, perhaps, must fall under the rubric of radical insufficiency in filmic sensibility and the vocabulary of film criticism. In fact, I am reminded of the professor who perished in the

great Johnstown Flood. When he arrived at the Pearly Gates, St. Peter welcomed him and invited him to give a paper on the flood at the All-Heaven Conference on Floods. The professor, not sure of his rank and tenure in his new location, agreed to do so. St. Peter seemed pleased, then concerned. With the air of a Conference Program Chair, St. Peter told the professor: "One thing you may wish to bear in mind while presenting your paper on the flood—and, uh, that is, ah, Noah will be in the audience."

Or, to express the difficulty another way: in recent months, as I watched again and again the Edgar film of "Indian Camp," trying to see truly what is there, trying to form an exact *constatation*, trying also to block out the simultaneous unrolling in my mind of Hemingway's text, which I know by heart, which I have taught hundreds of times, I have often been reminded of the fabled beginning of that wonderfully awful television show, *Mission Impossible,* which is almost as bad as the films Hollywood has made from Hemingway's fiction. So another tape has been reeling through my imagination, too, and it goes something like this:

> Good morning Jim. . . . [here follows some discussion of corrupt dictators, depraved drug dealers or sinister terrorists, critics, or filmmakers who must be eliminated]. . . . Your mission, Jim, should you choose to accept it, is to discuss the making of a classic story that you love into a short film, and to do so in 20 minutes. As always, should you or any of your Mission Impossible force be caught or killed, the Conference will disavow any knowledge of your action. This paper will self-destruct in five seconds—or, shall we say, nineteen minutes.

Add to all of this the memory, the resonance as I write these words, of long, wet, cold, all-night location shooting of this film, in October-frosted mountains, from dark to cold dawn and dark to cold dawn again, and I believe I have given an honest critic's account of my biases, intentions, and personal engagement with the subject at hand.

Let us proceed from certain facts and interpretations concerned with the fiction and move towards observations about the film. "Indian Camp" is one of Hemingway's earliest stories, his first short story for which he was paid—earning less than ten dollars in 1924. It is widely agreed that it is one of his greatest stories. Here is how one recent authoritative study sums up the matter:

> Hemingway's fourth story, written under some duress on his return to Paris in 1924 and published almost immediately, has never been seriously challenged as the profound and original work of fiction it is. It has appealed to all the critical schools and survived them all with something left unanswered, perhaps, unanswerable. It has invited and evaded psychoanalytic and archetypal analyses. Sociological interpretations seem dated confessions of the 1960s. . . And, finally, the story, as we all know, cast a long shadow, which Hemingway witnessed four years later and at the end of his life.[1]

This last is, of course, a reference to the story's concern with suicide and the subsequent suicide of both Hemingway and his father. Along with such biographical soundings, "Indian Camp" has attracted a wide range of readings, most of which agree on at least two points: 1) It is a tale of initiation, and as in most male initiation stories the relationship of father and son is crucial; 2) the primary focus of the story is the boy's epiphany—or lack of epiphany—derived from the shocking experience of a violent sequence of birth and death; and 3) although this birth-death cycle is much richer when the story is viewed in the full context of *In Our Time,* "Indian Camp" is one distinct and discrete section of the larger whole which does not collapse when removed from this contest. "Indian Camp" stands alone admirably well, even without the novelistic reverberations of *In Our Time,* of which it is the original opening story (i.e., in the 1925 edition). These are the points of general agreement. What, then, are the radically divergent views?

Here follows a list of key points as defined in the extensive critical commentary the story has generated, together with brief summaries of the views of various Hemingway critics:

1. Why does Uncle George, when the white men arrive across the lake for the emergency delivery of the Indian woman's baby, give out cigars to the Indian men? There has been a great deal of heated discussion of this point, with one side arguing that Uncle George is obviously the father of the Indian baby.[2] This view is then used as underpinning for arguments about the white man's "rape" of the Indian world, his "intrusion" in and "destruction" of that "primitive" Native American life and culture. A tremendous burden of social guilt is imposed upon the white men in this reading of the story. Such politicized or "sociological interpretations," as Paul Smith suggests, now carry a strong whiff of the 1960s.[3] Later discussions of the story have stayed closer to the text, ignoring or dismissing the question of Uncle George's paternity; some view those cigars as an offering, a ritual gift of tobacco, a perfectly normal event in traditional societies, American or Native American.[4] This seems to me the more accurate view, although Hemingway may have produced those cigars to tease the question of paternity and thus the motive for the Indian man's suicide. At any rate, the cigar question has so vexed generations of Hemingway critics that Philip Young, one of the fathers of the field, finally confessed that he, not Uncle George, was the father of the Indian boy.[5] Nice try, but no cigar.

2. Why does the Indian man commit suicide? This question has been viewed as central to, or peripheral to, the story's main concern. Does he slit his throat because he has a badly cut and infected foot? Because he cannot bear his wife's screams of labor? Because he cannot bear the presence of the white men in his world? The white doctor cutting his wife? For a few critics the Indian father is the central character in the story. He is variously seen as the symbol of the "death of a civilization"[6] as a kind of last warrior, resisting the white man's intrusion" in this "primitive" world, rejecting the conventional white man's role of

the "proud father," as a man whose "cut foot suggests an unconscious desire for castration deriving from his guilt for his wife's suffering."[7] For one biographical critic, the Indian man is "Hemingway's symbolic equivalent of himself" in his agony over the birth of his first son and the Indian's suicide is a kind of prophecy of things to come in Hemingway's life.[8] Other readings see the man's role as peripheral; he is there simply to underline the sudden, violent, and inexplicable juxtaposition of life and death, which is Hemingway's primary theme throughout *In Our Time*.

3. What kind of man is Nick's father, Dr. Adams? Some critics have argued that the story sharply focuses on the inadequacies and insensitivities of Dr. Adams. Again, such views tend to date from the 1960s, although I gather the story is still being taught in this fashion. Paul Smith sums up the "charges" that have been brought against the doctor—"arriving improperly prepared, ignoring his patient's pain, belatedly considering the husband's suffering"—and concludes that these strained readings of Dr. Adams "have been answered as they deserved to be."[9] More recent critics have acquitted Dr. Adams of the charges earlier commentators brought against him. George Monteiro, for example, stresses the necessity, for a physician, of that "effective neutrality" which enables "one's medical training and objectively learned technique to control one's behavior."[10] This is on target, but I would go beyond to assert that Dr. Adams is Hemingway's earliest instance of an exemplary character performing with "grace under pressure"—performing well even though improperly equipped, doing the best he can—based on discipline and knowledge—in difficult and violent circumstances. And it is important to stress, too, as recent observers have, that Dr. Adams is a loving father to his son.

4. What is Nick's epiphany? What does he learn, or fail to learn? This is, of course, the central matter and it has elicited a good deal of subtle discussion, far too complex to summarize here. It all hinges on that famous last line of the story: "He felt quite sure that he would never die." The critical frontlines face each other on the battleground of

this unexpected concluding revelation, firing volleys from entrenched positions. One side feels that this sentence indicates that this is an ironic tale of Nick's *failed* initiation, his epiphany not realized, or an epiphany that is romantic and illusory. For example, Nick's assertion of immortality is a mere "romantic reaction to the experience"[11] and he has not comprehended "the tragedy he has witnessed."[12] The opposite side holds that the ending is "neither illusory nor ironic" but very apt, especially because Nick here apprehends his father's love, which "reinforces his sense of being, and of immortality."[13] This comes much closer to the mark, I think, and such readings are reinforced by Paul Smith's report on the "Indian Camp" manuscript, on Hemingway's ultimate addition, in his final revisions of the manuscript, of that entire last sentence: "In the early morning of the lake sitting in the sterm of the boat with his father rowing, he felt quite sure that he would never die." Smith correctly stresses that the introductory phrases here are "necessary conditions for the rest of the sentence," i.e., at that moment and in that place, Nick feels "sure" he will never die. However, issue might be taken with Smith's implicit construction of an alternative sentence that might read something like this: "In the dark night alone on the lake thinking of the Indian woman screaming and the man slitting his throat, he felt quite afraid of dying." Indeed there is uncharted terrain, largely ignored by Hemingway criticism and not directly pertinent to the making of the fiction into film under consideration here, for it requires precise attention to the so-called Hemingway story, "Three Shots," which is a prologue to "Indian Camp" in the manuscript stages. "Three Shots" yields yet another angle on Nick's feelings of immortality. This early manuscript version of "Indian Camp" focuses on Nick's fear of death, as he experiences it in church, singing the hymn he calls "Some day the silver cord will break." Hemingway's work evinces a lifelong concern with Christian categories of the soul and its disposition, here and hereafter, and he weaves a design in "Three Shots" and "Indian Camp," taken together, which traces Nick's movement from fear of the loss of the soul (the "silver cord" breaking)

to a sense of being "saved by grace" ("Saved by Grace" is the actual title of the hymn). In "Indian Camp," the grace may inhere in Nick's witness to his father's saving grace, his "grace under pressure" in cutting that umbilical cord and bringing new life into the world, and a subsuming grace may be present in a larger religious sense, as it so often is—though so seldom recognized—in Hemingway's later fiction.

These, then, are the four key points in the accumulated commentary. How does Brian Edgar's film deal with these contented touchstones?

1. The Uncle George question: happily, Edgar does not treat Uncle George from the paternity angle. However, for reasons not entirely clear to me, in the film Uncle George gives out the cigars on the "white man's side" of the lake. Since I was, after a fashion, an understudy for the film role of Uncle George, and since I was present on location for the shooting of the cigar scene, I should be able to say something more cogent about the reason for the shift, other that to mention that the physical facts of the shooting terrain dictated this choice. In my early readings of the screenplay I did not notice this shift of location; thus I did not discuss the matter with the director. In any case, if Uncle George's putative paternity is dismissed, the cigars then become formal offerings, ritual gifts, appropriately given on the "white man's side" *or* the "red man's side" of the lake (if we simply must view the matter in terms of clearly defined "sides"—obviously, I do not think we must). An interview, published after the film's world premiere in April 1990, sheds some light on Edgar's view of the cigar question:

> HRS: What do you think of the notion, advanced by some critics, that Uncle George is the father of the baby? The cigars and all that?

> BE: A fascinating idea, and it was H. R. Stoneback who first told me this when we were scouting locations for the Indian camp. This would have made an interesting version, but for film (where this would have to be shown or suggested), it could become too easy a resolution.[14]

99

Precisely. Two final notes on changes involving Uncle George:" his already minimal role in the story is reduced even more in the film, especially his speaking part; for example, the deletion of his most memorable line, "Damn squaw bitch!", uttered when the Indian woman bites him. Perhaps this deletion reflects the film's postmodern solicitousness with regard to Native American sensibilities. Also, in the film the director supplies him with a rifle to carry into the Indian camp— more on this in a moment. In sum, the film treats Uncle George as more or less the same figure of comic relief that he is in Hemingway's text.

2. Why does the Indian man commit suicide? This is one of the more vexing questions in this fiction-into-film process, and here we find Edgar's greatest divergence from Hemingway's story. In the fiction we know that the Indian man has a very badly cut foot and is thus suffering his own misery. We do not know this in the film, though there is a fleeting and extremely minimalist suggestion of the wound. In Hemingway, the Indian man plays almost no role—he is actively *present* in the story of a brief passage before he rolls over "against the wall" and out of the angle of vision of the narrator and reader until his quiet suicide is later discovered. In Edgar, however, he holds center stage for a time and his fadeout into the shadows of his bunk is moved forward in the stream of action. Edgar's invention here is the significant *presence* of the Indian man, first in the intensity with which he regards his wife's screaming, and then in the eye contact he makes with Nick. In the screenplay, Edgar describes this as follows:

> Slowly, he turns his head. His eyes meet Nick. Closer angle
> on Nick, looking up at the man. HOLD. The man looks
> straight at him: an expression steeped in a pain and knowl-
> edge Nick can't understand. An unspoken connection. The
> man smiles. Nick, next to his Father, smiles back.[15]

Of course, none of this is in the story, not the faintest hint of this sense of "connection" between Nick and the Indian man. This rather radical change may be seen by viewers of the film who know the story as

primary skewing of Hemingway's story line, forcing a filmic metamorphosis of the tale into the "metaphor of intrusion" which Edgar sees as the "meat of the drama."[16] More light is shed on this matter in Edgar's published interview:

> HRS: When we were discussing this before you made the film, didn't you say that Milos Forman or Vojtech Jasny told you that you must decide why the man committed suicide before you could make the film? Hemingway, of course, doesn't tell us—he never does. Students reading the story in my classes love to argue about this question. What did you finally decide?

> BE: I resisted the belief that one must know why the Indian man killed himself. Part of the enigma in my version is that, in the end, Nick's father has no answer. But standing in the Native American's shoes, I came to believe that this man had lost face when his child could not be born, and amidst his wife's screams, the arrival and touch of the white man became too painful.[17]

Clearly, crucial questions of taste, history, and politics may be involved here, but it is manifest that Edgar's version of Hemingway is very much a post-1960s "Indian Camp," a Native American tale for the 1990s.

3. What kind of man is Nick's father, Dr. Adams? This may be one of the film's strongest points: Dr. Adams is not convicted of the silly charges brought against him by some Hemingway critics. Both the director and the actor (George Dickerson) who portrays Dr. Adams understand his character and his role in the drama, and the film brings him vividly to life.

4. What about Nick's epiphany? Obviously, this is the most difficult matter to translate from fiction into film. Edgar brings a sense of complexity and subtlety to the question, and Nick's comprehension and awareness is handled with delicacy by director and actor (Sean MacLean) alike. The film flows smoothly but deeply over the risks and dangers here, and treats the conclusion with even greater understate-

101

ment than the story does. I'll return to this question in my concluding remarks, together with some consideration of the problems posed by Hemingway's nuanced handling of Nick's epiphany and the various ways of getting it on film that Edgar entertained and rejected.

Along with the film's treatment of these four key points, we should note briefly the responses of Hemingway scholars and critics to the film. It is rather early in the game to have any responses to the film in print. However, since I introduced the film and moderated discussion sessions on several occasions, including its first major screening, for the Fourth International Hemingway Conference at the John F. Kennedy Library in Boston (July 1990), I have gathered quite a dossier of "oral reviews" from Hemingway purists, most of whom are firmly settled in the conviction that film cannot possibly do justice to the resonances and nuances of Hemingway's alchemy. These "reviews" could fill twenty or thirty pages, but I will briefly sum up the points I have heard repeated again and again. Under the rubric of the film's strengths I have heard much admiration expressed for 1) the portrayal of Nick and his father; 2) the invention of the scene with Nick in the night forest, necessary perhaps to cover a time lapse in Hemingway's text; 3) the skillfull and eloquent broken beads sequence, another Edgar invention; 4) the sound, the light; and 5) the film's visual power, and its haunting sense of Hemingway's silence (that quality of Hemingway's prose which is usually attributed to his "theory of omission" or his "iceberg theory" of writing). Under the rubric of regrets, or disappointments with the film, the following responses are predominant: 1) politicization or "Indianization" of Hemingway's real story, thereby cultivating a "metaphor of intrusion" and diminishing the thrust of the tale of initiation, the father-son story that Hemingway tells; 2) the radical cutting of dialogue, especially the final conversation between father and son; 3) a blurring of Nick's epiphany; 4) the loss of the story's final image, Nick's hand trailing in the water as he feels sure "that he would never die." Rebuttal of the first critical objection, or "regret," is difficult: the film's agenda does include, high on the list, the metaphor of the white

man's "intrusion" cited above in Edgar's overview remarks. It is probably necessary to stress that this reflects neither Hemingway nor history. The Native Americans of Hemingway's Michigan were assimilated into the rural life of the region; they did not have names like "Echohawk" and "Running Elk" (as Edgar names them in his screenplay); they did not wear feathers and buckskin and beads as they do in the film; Hemingway's Indians used rowboats, not the cliché canoes of the film; Uncle George, who is on a *fishing* trip, does not, in the story, carry a rifle into the Indian camp as he does in the film; moreover, the somewhat tense atmosphere, the edge of threat, as exemplified in the film, for example, by one Indian's rather sharply and ominously presented knife, is not a part of Hemingway's story, which is *about* a boy and his father, a doctor on a fishing trip who comes when the Indians summon him, a generous and humane doctor answering a call for help, doing the best he can in difficult circumstances, presiding skillfully over birth of new life in the Indian camp. Far from being a "intruder," he is a savior, a bringer of new life. And when he washes his hands for his operation it is *not* a piece of Pontius-Pilatery, for he bears no guilt, no responsibility for the suicide of the Indian man: he admirably meets his one responsibility—to deliver the baby.

Response to the second objection of many viewers is likewise rather difficult, for it involves the truncation of one of the most cherished dialogues in Hemingway's fiction, indeed, some would say, in American literature. In Hemingway it reads as follows:

> "Do ladies always have such a hard time having babies?" Nick asked.
> "No, that was very, very exceptional."
> "Why did he kill himself, Daddy?"
> "I don't know, Nick. He couldn't stand things, I guess."
> "Do many men kill themselves, Daddy?"
> "Not very many, Nick."
> "Do many women?"
> "Hardly ever."

"Don't they ever?"
"Oh, yes. They do sometimes."
"Daddy?"
"Yes."
"Where did Uncle George go?"
"He'll turn up all right."
"Is dying hard, Daddy?"
"No, I think it's pretty easy, Nick. It all depends."

In the film all of this is reduced to:

"Why did he kill himself, Daddy?"
"I don't know, Nick."
"Is dying hard?"

Thus Hemingway's sixteen lines of dialogue, carrying all of the story's gravity and resonance, are reduced to three lines. It may be hard to explain to a non-Hemingway audience how much esteem—nay, reverence—centers on these lines as Hemingway wrote them. Even the loss of the "Daddy" after the final "Is dying hard?" has been construed as meddling with the pure and precise poetic form of the passage. As one Hemingway purist observed: "You don't mess with Hemingway's dialogue just as you don't mess with or modernize Shakespeare's." This problem—and it seems to be the major one the Hemingway aficionados have with the film—is further underlined by the fact that the story's 402 words of spoken dialogue are reduced to 259 words in the screenplay, and further reduced to a mere 169 spoken works in the film. I raised this matter in my interview with Edgar, who was well aware that Hemingway's dialogue was his "biggest single challenge":

HRS: Many Hemingway purists will miss the father-son dialogue which concludes the story. Why did you choose to truncate this sequence? Too talky for film?

BE: I"ll probably get stoned for saying this, but I feel the last exchange between Nick and his father is the weakest part of the story. For me, the real significance lies in what is

not said. While part of the dialogue we shot got cut in the editing—the result of not "translating" well to spoken words—this final scene I always saw as father's inability to answer..[18]

Thus, for Edgar, the "weakest part" of the story is the sequence that Hemingway critics tend to see as the indispensable scene, the "strongest" part. Perhaps we may account for this by positing the existence of an unbridgeable chasm between the literary sensibility and the film sensibility. Perhaps not.

As for the other critical "regrets" most often raised about the film, number three above, the so-called blurring of Nick's epiphany, seems inextricably bound up with the loss of the concluding dialogue. However, I am not in full agreement with those who feel that Nick's epiphany is "blurred." Surely the amplitude of such an epiphany is greater in the medium of the written word, particularly in the full context of Nick's fear for his soul and larger questions of immortality which are present throughout the complete contexts of "Three Shots" and "Indian Camp" and *In Our Time*—complex matter indeed, which Edgar could not possibly include or evoke in a short film based solely on "Indian Camp." Given what I understand to be the more limited possibilities of film in this regard, Edgar brings across as much as he can of Nick's epiphany rather sharply. Perhaps especially so, for viewers who do not know the fiction. The final "regret" of some viewers, the loss of the image of Nick's hand trailing in the lake at sunrise, together with the content of the story's marvellous final sentence, is explained by Edgar as follows:

> BE: This image [Nick's hand trailing in the water] I desperately wanted, but unfortunately time and money kept me from having it. I had intended to shoot this last scene at dawn, as it appears in the story. But we had only two nights to shoot at the lake, and to have done this scene would have required consecutive dawns after shooting from 8 pm. - 4 am. Nick and his father would have been zombies. We had

to compromise with a pre-dawn scene, shot the last morning. (In fact, Nick's hand was trailing in the water, but you can't see it.)

HRS: You entertained various options, the use of voice-over, the introduction of Nick-as-old-man: Why did you reject these devices?

BE: Originally, I wrote this last narrative line of the story as voice-over, but realized this would sound clichéic. I then created the image of Nick as an old Man, which would have been the last image of the film: suggesting his reflection back on this time. We shot this, but during the editing it confused too many people—including Milos Forman. I decided finally to end on Nick's image of his father..[19]

Thus we see that some of the difficulties of making this film, and some of the objections of Hemingway purists, are rooted in literary and aesthetic problems, some in political and historical visions and realities, and some in dollars.

In conclusion, speaking now as a novice in the arena of film, I would like to say this: In the process of serving as a consultant in the making of this film, I learned a good deal about the physical and fiscal realities of filmmaking, about the risks, the extraordinary difficulties and delicacies of making a film from a classic work of fiction. Brian Edgar tells me that he was first drawn to "Indian Camp" by its "visual poignancy," by its "profoundly compelling" visual power. Seeing his film, I understand—but cannot articulate—this quality better than I did before. It is, I think, visually stunning. I will not pretend to understand what I can only call the mystery of the transformation of a great story into a fine film. Even with all of the reservations of the Hemingway purists—some of which are my reservations, too—this film works, and works beautifully. One viewer summed it up this way; "Edgar changes much, omits some, and misses some of Hemingway's story. Still, it is by far the best Hemingway film yet." I think of the chilly all-night shooting on location, of certain physical difficulties and solutions dic-

tated by terrain and weather, of flat tires on equipment trucks, of the burden of knowledge that, in a project already entangled in cost over-runs, it would cost thousands of dollars more merely to film a few sec-onds of a boy's hand trailing in the lake water, and I say, oh yes, Edgar's "Indian Camp" is a great success. I think of Hollywood's hor-rendous mish-mash of Hemingway movies, of Anthony Quinn's recent disastrous *Old Man and the Sea* on television, of Joan Didion's morally confused and bungled screenplay for HBO's flat version of "Hills Like White Elephants" (with James Woods and Melanie Griffith), and I conclude that Edgar's film is indeed the best Hemingway movie yet. And somewhere in the back of my mind I hear this dialogue:

"Is filmmaking hard, Daddy?"
"It all depends, Nick."

Then a voice echoes during the fadeout: In the early morning, he felt quite sure that he would never make a film. But he would have to write about it.

NOTES

[1]Paul Smith, *A Reader's Guide to the Short Stories of Ernest Hemingway* (Boston: G.K. Hall, 1989), 41.

[2]Kenneth Bernard, "Hemingway's Indian Camp," *Studies in Short Fiction* 2 (Spring 1965), 291; Gerry Brenner, *Concealments in Hemingway's Works* (Columbus: Ohio State Univ. Press, 1988), 239; Thomas G. Tanselle, "Hemingway's 'Indian Camp'," *Explicator* 20 (Feb. 1962), Item #53.

[3]Brenner, 291; Joseph DeFalco, *The Hero in Hemingway's Short Stories* (Pittsburgh: Univ. of Pittsburgh Press, 1963), 28-30; Tanselle, Item #53.

[4]George Montiero, "The Limits of Professionalism: A Sociological Approach to Faulkner, Fitzgerald and Hemingway,"

Criticism 15 (Spring 1973), 146-152; Dick Penner, "The First Nick Adams Story," *Fitzgerald/Hemingway Annual* (1975), 195-199.

[5]Philip Young, "Letter to the Editor," *Studies in Short Fiction* 3 (1966), ii-iii.

[6]Bernard, 291.

[7]Smith, 39; Tanselle, Item #53.

[8]Kenneth Lynn, *Hemingway* (New York: Simon and Schuster, 1987), 229.

[9]Smith, 39.

[10]Montiero, 147.

[11]DeFalco, 32.

[12]Arthur Waldhorn, *A Reader's Guide to Ernest Hemingway* (New York: Farrar, 1972), 54.

[13]Penner, 202.

[14]H.R. Stoneback, "Interview with Brian Edgar," *English Graduate Review* II (April 1990), 6.

[15]Brian Edgar, "'Indian Camp': Screenplay," *English Graduate Review* II (April 1990), 13.

[16]Stoneback, 6.

[17]Stoneback, 6.

[18]Stoneback, 5-7.

[19]Stoneback, 17.

10. *REAR WINDOW'S* LISA FREEMONT: MASOCHISTIC FEMALE SPECTATOR OR POST-WAR SOCIOECONOMIC THREAT?[1]

Carol Mason

ALFRED HITCHCOCK'S *REAR WINDOW* (1954) is usually critiqued in terms of psychoanalysis. Feminists in particular have used the theories of Freud and Lacan to make sense of the sexual politics of looking in this film. Seldom, however, has anyone extensively commented on the class conflict structuring *Rear Window's* narrative, despite its being the main conflict in the romantic subplot concerning Lisa Freemont (Grace Kelly) and L.B. Jefferies (James Stewart). In tracking this conflict, this essay focuses on the character of Lisa, who not only exemplifies the ambiguous power of "the female spectator" as theorized by feminists, but also stands as the "too perfect" affluent working woman, whose excessive socioeconomic mobility threatens Jeff in his post-war years. First I will discuss how *Rear Window* fits feminist-psychoanalytic film theory, elaborating on Lisa's "spectatorship"; then I will trace a shift in discursive control that results

in Jeff's appropriation and management of Lisa's social and physical mobility.

Rear Window has been said to exemplify the voyeuristic man and the fetishized woman, the psychoanalytic pairing that Laura Mulvey claims is a structuring component of classic film. According to Mulvey's logic, posited in her landmark 1975 article "Visual Pleasure and Narrative Cinema," the immobilized photographer L.B. Jefferies is the voyeur, and Lisa Freemont, fashion model and high socialite, is the fetishized spectacle, a "passive image of visual perfection."[2] The film supposedly adopts Jeff's point of view, one which psychologically parallels the little boy's gaze as theorized by Freud and Lacan. Lisa's spectacular image psychologically parallels the image of woman as a penis-less body, the sight of which instills a fear of lacking the phallus—a castration anxiety that can be overcome by converting that image of lack, woman's image, into a fetish. Fetishizing what one fears puts distance between the fearful one and the feared one, and constitutes (still according to psychoanalysis) the former as subject and male and the latter as object and female. That is, fetishizing woman's image converts it from a site of anxiety to a sight of "visual pleasure."

But in narrative cinema, argues Mulvey, the fetishized woman cannot completely neutralize castration anxiety; as a result of this failure, cinematic looking has a contradictory structure that vascillates between the disruptive threat of castration caused by woman's image and the "visual pleasure" of fetishizing it. Says Mulvey, in *"Rear Window*, the look is central to the plot, oscillating between voyeurism and fetishistic fascination."[3] According to Mulvey's logic, we experience such oscillation when the camera (hence spectator) pauses to take in the glamor of Lisa/Grace Kelly or to ogle the dancing of Miss Torso, for example.[4]

It's difficult to argue that this psychoanalytic pairing of the voyeuristic male and fetishized female *isn't* structuring *Rear Window*; indeed, it seems as if the movie was made for such interpretation. *Rear Window* so matches psychoanalytic lore I think because Hitchcock

helped to produce that lore, to distill Freudian discourse for mass consumption, understanding, and acceptance. According to Richard Dyer, Hitchcock and the 1950s so popularized Freudian concepts of sexuality that "a whole world of reference [to psychoanalysis] could be summed up in a jaunty abbreviation: psycho."[5] I'm not arguing against the psychoanalytic readings of this particular film because they say a lot about how psychoanalysis, or "psycho," became a prominent ideological force in American popular culture and in the social construction of (hetero) sexuality in late twentieth-century America. Especially with his insistent and repeated indictments of a movie-goer as unethical voyeur, Hitchcock helped to create (rather than expose) a politics of looking, one gendered according to notions that were emerging in the 1950s about sexuality as natural and truthful.[6]

Like Dyer's work, my reading of the film adds dimension to the feminist-psychoanalytic critiques of *Rear Window*. This reading shows how class conflicts augment the sexual politics of looking, and indicate that Lisa Freemont is more than a model for the masochistic female spectator—she also symbolizes the threat of white women's economic mobility, which escalated during World War II and was squelched in post-war years. The scene which introduces Lisa establishes her as powerful and threatening as well as fantastically beautiful, and posits looking as a political act in socioeconomic terms as well as in sexual terms.

The scene begins with a pan around the courtyard and into Jeff's apartment; of the five pans in the film, only this one is "authorized" by any character.[7] Previously we have no sense of someone executing that look around the courtyard, but in this scene, it appears to be Lisa, when we discover that it is her ominous shadow creeping over sleepy Jeff. She is not a "passive image" but rather an active looker. Even as these shots posit Lisa as a spectator if not voyeur, her spectatorship gives way to dazzling spectacle when she turns on each lamp and poses for Jeff. The posing certainly is self-conscious; she knows what is expected of her, and she gladly fulfils the role because she prospers greatly from it.

As someone who "wears a new dress every day. . . only because it's expected of her," she can flaunt her prosperity with gifts of a new silver cigarette case and an elegant meal, brought in by a uniformed man whom she pays forthrightly, with enough to cover the cab. Thus she exhibits not only a fetishistic image of herself or her clothes; she also flaunts her power in creating and prospering from those fetishized things.

This scene raises the question of how and why being looked at is less powerful than looking. This is not a naive question, but one which interrogates the fundamental feminist/psychoanalytic assumption that being looked at is passive behavior. Certainly Lisa Freemont is quite active in her attempts to attract "the gaze." But several critics see her deliberate behavior (Mulvey calls it her "exhibitionism") as the mark of a masochist.

Like the "female spectator" of Hollywood movies who "can love, accept and give a positive value to these films only from her own masochism"[8], Lisa seems a willful victim of a sexist enterprise—the fashion world, or Jeff's own heterosexual fantasy—that demands her own participation in her ideological demise and political disenfranchisement.

This argument accepts rather than rejects the premise of the dichotomy between the male/subject/voyeur and the female/object/fetish. Some feminist critics have reversed this dichotomy to study women as active spectators;[9] one critic has broken the dichotomy by theorizing the gaze itself as object, as the thing desired;[10] and others have entirely denounced the totalizing notion of "a spectator," since it assumes a universal subjectivity and doesn't account for cultural differences.[11] Although Lisa is an active viewer who doesn't "look only to be looked at" (as John Berger in *Ways of Seeing*, suggests all women do), "Lisa" can be theorized just as effectively as a character with personal motives, not only as a symbol of white women's socioeconomic threat to men in post-war America. In any case, the power relations in *Rear Window* cannot be contained by

discussions about sexual or romantic/marital conflict.[12] Lisa exemplifies not only the ambiguous power of the female spectator, but also the "perfect" upper-middle class woman who has financial and intellectual resources, not to mention two working legs, that Jeff appropriates. He steals her ideas (her intellectual labor) and manages her physical movement (her manual labor) until he is the one in control of what gets said, heard, and done. This is a great shift from the beginning of the film when Lisa and Stella are the ones in discursive control, the ones who have authority due to their specific understandings of how bodies work.

As a professional nurse, Stella knows that human bodies are political things tied directly to economics. With her understanding that one man's diarrhea symbolizes a whole company's and a whole country's economic collapse, Stella says she predicted the 1929 market crash. "When General Motors has to go to the bathroom ten times a day, the whole country's ready to let loose," she explains. We laugh at her with Jeff, but we can't deny her knowledge: "Crashed, didn't it?" she asks, and Jeff raises his eyebrows as a gesture of concession. While Jeff can't deny her knowledge, neither can he manage it at this first stage of the movie. Stella clearly out-talks him, dominating and interrupting the conversation about marriage. Stella is in discursive control, unmanageable by Jeff at this stage; but compared with Lisa's, her control is limited to farce.

Lisa's discursive control goes hand in hand with the control she has over her own body/image, because both are integrated in her work as a model, an occupation with a social status that threatens Jeff. Like Stella, Lisa can out-talk (and out-walk) Jeff at the beginning of the film, but Lisa is more threatening to Jeff because she's wealthy. As a model *and* socialite, she is unusual in understanding image as inevitable and workable; she seems to work the fashion industry rather than vice versa. Indeed, we learn that she has business meetings with a designer at the Waldorf and with the "Harper's Bazaar people," and when asked facetiously what someone was wearing, she remarks on the quality of

the fabric, specifying it as imported from Italy. Although such detailed knowledge of the trade is trivialized by Jeff, he admits to being "afraid of" Lisa's influence when she tells him she could get him a "dozen assignments by tomorrow." A fight about marriage ensues; just when Jeff gets aggressive enough to tell Lisa to "shut up," she puts him down again by appealing to her high social status and its conventions of proper conversation. She tells him she won't listen to him if his "opinion is as rude as [his] manner." As she prepares to leave, dressing her hands in white gloves (another indication of "high" society), Lisa explains her position. "I'm in love with you, I don't care what you do for a living," she says, thereby underscoring her superior socioeconomic standing as the major conflict between them. Moreover, that socioeconomic standing is clearly tied to her knowledge about managing herself as body/image.

But Lisa soon learns that such knowledge is considered excessive. She witnesses two assaults on two characters—Miss Lonelyhearts and a neighbor's dog—who are both clearly identified with Lisa. Contrary to one critic's suggestion that Jeff, Lisa, and the viewers respond to Lonelyhearts' assault identically[13] I agree with Tania Modleski that

> Lisa can be seen staring even more intently than Jeff. . . .
> As Lisa stares and Jeff looks away in some embarrassment,
> the song "Mona Lisa" is heard, sung by drunken revellers at
> the musician's party. The title of the song suggests an
> important link between the two women (it's only cause
> you're *lonely*, Mona *Lisa*).[14]

In addition to this audible connection that Modleski points out, there is a definite visual one.

The visual link between Lisa and Lonelyhearts at this point is their clothing. Hitchcock said he kept the color green reserved for Lonelyhearts so there would be no mistaking who is going across the alley to the bar.[15] When Lonelyhearts is assaulted by a young man she brings home from a bar, Lisa is dressed in a pale green suit, a much subtler version of the hue reserved for Lonelyhearts.[16] In fact, and

appropriately, the dress Lonelyhearts wears is emerald and iridescent, the brightest dress she's worn yet (others were bluish or olive green). After the assault scene, Lonelyhearts won't wear green again; we see her in a blue bathrobe and a print dress. This emerald green dress is her crescendo, her moment of crisis; the intensity of the color matches the intensity of the situation, which is dramatic in its shift from scarcity of male attention to excess of male attention, a shift that corresponds to Lonelyhearts's newly-adopted aggressive behavior.

Previously, Jeff alone watches Lonelyhearts get aggressive by donning this especially intense green dress, irresistibly adding another quick stroke of lipstick, swigging some whiskey, squaring her shoulders and marching out to get a man. Here Lonelyhearts mirrors Lisa's sexually aggressive action, as well as her wardrobe and accessories; both women wear a green outfit, bright red lipstick, and a large charm bracelet. Clearly, Lonelyhearts (like Lisa), knows how to sell herself, employing a knowledge of body and image and how they work in the heterosexual economy. What's new in Lonelyheart's scenario is that having and using this knowledge is punishable by assault.

Jeff looks away as Lonelyhearts cries in the aftermath of this assault, but Lisa watches more intently, as if recognizing or trying hard to understand this. Then Lisa leaves Jeff's side for the first time since Detective Doyle spoke his mind about leaving "private worlds" private, and puts the biggest distance seen in the film between her and Jeff inside his apartment. She crosses over to the fireplace and turns her back on Jeff, as he starts to agree with Doyle that private worlds should remain private. In other words, according to the men, what Lisa just saw—a sexual assault—should be kept a secret, unpublicized. More suitable for public outcry, apparently, is the murder of a dog, an incident which serves as a second example or warning for Lisa, telling her that excessive knowledge, like too much female sexual aggression, is punishable.

The dog, like Lonelyhearts (who retrieves the dead animal for its owners), is punished for excessive knowledge: the dog "knew too

much," as Lisa says significantly.[17] Lisa, who Jeff says is "too perfect," recognizes that the dog knew too much; she watches Lonelyhearts, who knows too well how to attract a man, sorrowfully place the dead dog in a basket. Thus the three are connected for their "excessive" knowledge and their desires to act on it. And Lisa witnesses in this second assault another example of what could befall her as a woman of excessive know-how, a too perfect woman who knows too much.

Following this second warning that excessive knowledge is punishable, Lisa's aggression shifts from being directed at Jeff in a sexual manner to being directed *by* Jeff in a managerial way. Although she takes the initiative and can be seen as defying Jeff's wishes by entering Thorwald's apartment, it is Jeff who first clears the way by getting Thorwald out of the apartment with a misleading phone call. As her aggressive actions thus come under Jeff's management, Lisa's work and clothes start to resemble Stella's. No longer using eleven-hundred-dollar gowns to attract Jeff sexually, she scales fire escapes and climbs through windows in a modest cotton print dress, which results in Jeff's lusty admiration for her, as many critics have noted. Now both women are doing Jeff's dirty work while he appears more powerful and knowledgeable, coming up with ideas and giving commands that are heard and obeyed for the first time in the narrative.

For example, Jeff's voice, which previously wasn't strong or assertive enough to win any argument (with Stella, Lisa or Doyle), finally gains authority when he talks to Doyle's babysitter. Unlike Mrs. Doyle, who earlier called him an "idiot," her surrogate, the babysitter, responds to Jeff as an authority. Jeff's voice then seems to gain power as it actually directs Thorwald to answer a ringing phone: "Come on, Thorwald, pick it up. You're curious. You want to know if it's your girlfriend calling, the one you killed for." This idea of Thorwald having a mistress was at first Lisa's interpretation. Similarly, the knowledge of jewelry was initially Lisa's, but now it is Jeff who comes up with the idea that the wedding ring would specifically prove the murder. Thus,

Lisa's knowledge is appropriated by Jeff, who at last begins to be in discursive control.

Also, and more significantly, the control and knowledge of money matters shift from Lisa to Jeff. First, it is Jeff (not Lisa) who negotiates a "business meeting"—this time with Thorwald, not the Harper's Bazaar people—in a ploy to get the killer out of the apartment with the threat of blackmail. Second, when Lisa is in Thorwald's apartment she discovers Anna's empty purse, which she turns upside down in distress. This parallels a very significant finding on Stella's part. When Lisa gets caught, Jeff starts to look for money. Stella asks, "What do you need money for?" to which Jeff has a very specific answer about bail fees. For the first time, Lisa uncharacteristically has little money ("fifty cents," Stella discovers) in her purse, while Jeff has more. Given the major point of opposition between Jeff and Lisa—her socioeconomic superiority—this is a glaring reversal.

Also for the first time, Jeff has the "connections" that can help Lisa. Rather than Lisa's knowing people who could get him a "dozen assignments by tomorrow," it is Jeff's knowing Doyle that saves her. Jeff's social and economic power is fully developed, and his masculinity and heterosexual engagement is fully established now that he adores Lisa and the dangerous work she has done for him. With such power intact, at the end of the movie—despite two broken legs and 90-degree heat—he can smile instead of suffer as he did before with one impaired limb at the beginning of the film. He has no need for mobility, no need to move and work for himself, because he has learned to manage the manual and intellectual labor of Lisa and Stella. Thus his power is contingent, in a very capitalistic manner, on the appropriation and management of other peoples' bodies and knowledge. He has harnessed Lisa's physical and socioeconomic mobility, but it is an appropriation that has been overlooked because feminists have focused mainly on the sexual politics of the gaze.

Especially with its ending, *Rear Window's* conflicts can't be contained by a psychosexual reading of the politics of looking. It is Lisa

who has "the last look," according to Modleski,[18] and it is Lisa who seems successful in "domesticating [Jeff] while maintaining a submissive appearance," as Allen says.[19] But that "last look" is aimed at a magazine Lisa holds, not at Jeff. Hitchcock closes the film with a self-reflexive image of woman that speaks to more than domestic, heterosexual, romantic resolution. In Toles' words, the film ends when Lisa "exchanges the book of Himalayan adventure she is apparently absorbed in for another text (Harper's *Bazaar*) that claims her real allegiance."[20] Toles interprets this last look at the *Bazaar* as implying that Lisa can't change, despite the new casual clothes she's wearing (loafers, jeans, button-down shirt). She won't give up her gowns and high society (her "real allegiance") or her pursuit of Jeff. But I see no difference between what she wears at the close of the film and what she wears the first time we see her. The function of the dungarees and camp shirt is exactly the function of the eleven-hundred-dollar dress: she wears it "only because it's expected of her." I therefore resist the interpretation that *Beyond the High Himalayas* is merely a facade, and that the "real" Lisa Carol Freemont reads instead a *Bazaar* and would rather wear a dress. The *Bazaar*, like the dresses, is no less a facade than the casual clothes and adventure literature.

In fact, there is a stronger connection between Lisa's camp clothes and the *Bazaar* than there is between the jeans and *Beyond the High Himalayas*. Again using color to make strong associations, Hitchcock dresses Grace Kelly in a red shirt that matches the red dress worn by the *Bazaar* cover girl. Moreover, the cover girl, like Lisa, has a magazine in her hand. Lisa holds a magazine depicting a woman holding a magazine. This self-reflexive repetition calls to mind the mass-produced nature of woman-as-image, the very industry that Lisa thrives in, and foreshadows a postmodern notion of bodies as surfaces and screens.

But *Rear Window* is utterly a modern tale, whether Lisa is said to symbolize white women's threatening economic mobility in post-war America or white women's viewing position, that of the masochistic

female spectator. Instead of proving (or disproving) cinematic-psychoanalytic universals like the voyeuristic male and the fetishized female, it is most helpful to contextualize such universals in the historic framework and socioeconomic relations that a film addresses—even if that film is, like *Rear Window*, so intimately bound up with popular representations of "psycho"sexuality or with academic psychoanalytic discourse.

NOTES

[1]This paper was originally presented as *"Rear Window* and the Myth of the Masochistic Female Spectator." I am indebted in particular to Marty Roth and Paula Rabinowitz for its evolution, which is ongoing.

[2]Laura Mulvey, "Visual Pleasure and Narrative Cinema," *Screen* 16, no. 3 (1975), 6-18. Reprinted in *Feminism and Film Theory*, Ed. Constance Penley (New York: Routledge, 1988). Also reprinted in Laura Mulvey, *Visual and Other Pleasures* (Bloomington: Indiana Univ. Press, 1989).

[3]Mulvey, 13.

[4]A more blatant and hilariously parodic example of this contradictory structure of the (male) look that fetishizes woman's image occurs in a film distributed since this paper was presented. In *Wayne's World*, Garth's gaze at the waitress converts her image into a fetishized object that appears as an absurd close-up, disrupting the narrative action hyperbolically: the moment of fetishizing pushes Garth supernaturally away from the image, providing distance that renders the beautiful girl less a threat to shy Garth and more a vision of loveliness, an object of his funny fantasies.

[5]Richard Dyer, *Heavenly Bodies: Film Stars and Society* (London: Macmillan Publishing, 1987), 51.

[6]See Dyer's analysis of 1950s heterosexuality in "Marilyn Monroe and Sexuality," *Heavenly Bodies*.

[7]Robert Stam and Roberta Pearson, "Hitchcock's *Rear Window*: Reflexivity and the Critique of Voyeurism," in *A Hitchcock Reader*, eds. Marshall Deutelbaum and Leland Pogue (Ames, Iowa: Iowa Univ. Press, 1986), 202.

[8]Constance Penley, *The Future of an Illusion: Film, Feminism, and Psychoanalysis* (Minneapolis: Univ. of Minnesota Press, 1989), 43.

[9]Constance Penley, Mary Ann Doane, and Janet Bergstrom are among those who refuse the "bleak interpretation" of the masochistic female spectator posited by Raymond Bellour. Their refusal is based on women's power to look, and although they may be "dissatisfied with the fetishistic scenario as the basic model for cinematic looking and identification" (Penley 51), they do not get away from that psychoanalytic model. See Constance Penley's discussion of "Feminism and Film Theory" in her book *The Future of an Illusion* (Minneapolis, University of Minnesota Press, 1989).

[10]See Slavoj Zizek, "Looking Awry," *October* 42(1990): 31-55.

[11]The notion of the "female spectator" has been criticized for its heterosexist, racist, and occidental assumptions. For more on this, see the special issue of *Camera Obscura* devoted to the female spectator, volume 20-21 (1989).

[12]For an excellent reading of the film on this point, see Jeanne Allen's "Looking Through 'Rear Window': Hitchcock's Traps and Lures of Heterosexual Romance," *Female Spectators: Looking at Film and Television*, Deidre Pribram, ed. (London: Verso, 1988).

[13]Robert J. Benton, "Film as Dream: Alfred Hitchcock's *Rear Window*," *The Psychoanalytic Review* 71 (1984), 494.

[14]Tania Modleski, *The Women Who Knew Too Much: Hitchcock and Feminist Theory* (New York: Routledge, 1988), 81.

[15]Alfred Hitchcock, "Rear Window," *Take One* 2, no. 2 (1968), 42.

[16]Donald Spoto, *The Dark Side of Genius* (Boston: Little, Brown & Co., 1983), 348.

[17]Modleski, 75.

[18]Modleski, 85.

[19]Jeanne Allen, "Looking Through 'Rear Window': Hitchcock's Traps and Lures of Heterosexual Romance," in *Female Spectators: Looking at Film and Television*, ed. Deidre Pribram (London: Verso, 1988), 34.

[20]George E. Toles, "Alfred Hitchcock's *Rear Window* as Critical Aleegory," *Boundary 2* 16, nos. 2-3 (1989), 232.

11. REVOLUTION AS THEME IN JOHN OLIVER KILLENS' *YOUNGBLOOD*

Charles Wilson, Jr.

HAILED AS A "LANDMARK NOVEL of social protest," John Oliver Killens' *Youngblood* confronts Southern Jim Crow by making a very humane appeal to remedy past and current wrongs. Supplying the novel with its greatest impetus is the tension between evolution and revolution, or the conflict between slow cyclical progression and abrupt social upheaval. Various characters in the novel represent each of these battling forces. As they begin to interact, confusion oftentimes ensues, and as a result, compromise and melioration become obscured. Nevertheless, when the characters learn to temper their revolutionary spark with an acknowledgement of evolutionary practicality, or when they re-evaluate their definition of revolution, some social progress is realized.

Obviously, the characters who want immediate change are the blacks, who have for so long suffered economic and social hardships and who have patiently awaited minor societal changes. Opposed to them are the affluent whites, whose station in life is secured by strict adherence to the Southern Code of behavior: white domination over blacks. The characters who could potentially bridge these two forces

are the poor whites, who really do not benefit from acceptance of the Southern Code and who should align themselves with the blacks so as to effect rapid change.

As these characters in the novel develop, the battle becomes more poignant, internally and externally. We witness it foremost in Laurie Lee Youngblood, whose growth from childhood to adulthood is signaled by a transition from rebel antagonist to mainstream game player, or if you will, from revolutionary to evolutionary. It is this new vision for social change that she teaches to her children, Robby and Jenny Lee, who represent the future and hope for the Crossroads community, and who become the embodiment of evolutionary change. The link between these two forces is Richard Myles, the young school teacher from New York who encourages the Youngbloods in their struggle for survival. Myles represents radical change in his insistence on questioning all forms of authority, both black and white. But even he must learn to adopt new methods for surviving in the South. Oscar Jefferson, the poor white who befriends Joe Youngblood, ushers in the future when he and his eldest son risk their lives to help Joe after he is shot. Evolution and revolution are combined in the seemingly radical action taken by Oscar when he offers his blood to Joe. But his decision—merely humane, not radical—will begin the slow process of healing old wounds.

The novel opens with the birth of Laurie Lee, whose introduction into the world ushers in a new era, for she is initially the personification of revolution. Her birth on January 1, 1900, is no small coincidence. As the narrator informs us, Laurie Lee Barksdale began this life along with the brand new century; however, as we know, the new century will not begin for another year. Nonetheless, her birth is significant, because Laurie Lee will not only bring in a new era, but also dismiss an old one. With Laurie Lee, past wrongs will be righted, and former indiscretions will no longer be tolerated. Yet another important factor regarding Laurie Lee's birth is the exact date, Jan. 1, an important date in African-American history. Besides the fact that the Emancipation Proclamation was signed on this date in 1863, before that time it was also the date

when slaves were parceled out to other plantations, a day when they prayed they would be placed with kind masters. It was a day of much anxiety and frustration. That Laurie Lee should be born on this date is appropriate. She will strive to make Jan. 1 and all other days moments of true parity for blacks. In other words, she will continue the cycle— the evolutionary process—already begun in 1863.

As Laurie Lee begins to grow and mature, she resists the dictates of an overbearing Jim Crow society, refusing to be relegated to a position of inferiority, even if her resistance brings a penalty. At age twelve, while she is babysitting for a well-to-do white family, she ignores her employer's instructions when the woman insists that Laurie Lee call the little white girl "Miss." After Mrs. Tucker admonishes her again, Laurie Lee, standing "widelegged and defiant[,] [s]cared, mean and desperate," (9) snaps, "I said I hate that about you. That's what I said. Thinking I'm going to be calling a little pee-behind white gal *Miss*, you got another thought coming."[1] Laurie Lee knows that if she agrees to call Becky Miss Rebecca, she will have succumbed to the Code. Early in life, Laurie Lee is taught to defy the mandates of the larger society when it attempts to define her. And though she knows she does not have complete control over her life, she is aware that she should not willingly assist society in its abuse of her.

Even Laurie Lee's grandmother, a product of slavery, urges the young girl to demand her rightful place in the world, for the old lady asserts, "Fight em, honey, . . . especially the big rich onesThey the one took over where ol' marster left off. They lynch us and they work us to death, and it ain-na gonna change till you young Negroes gits together and beat some sense in they heads. So fight em, sugar pie."[2]

The advice that Big Mama offers is initially puzzling. One does not normally think of a humble old woman uttering such words; however, Big Mama is not the stereotypical elderly black woman sitting in her rocker, reading the Bible, and leaving her troubles to the Lord. She is a woman who has waited too long for life to change, and because she knows that she will probably not live to see marked change, she insists

that her children and grandchildren demand some improvements in society.

Big Mama's lessons do provide Laurie Lee with a strong foundation upon which to build a philosophy for survival. Above all else, Laurie Lee strives for dignity and pride, traits she instills in her own children, Jenny Lee and Robby. However, an almost overwhelming internal conflict arises when she must teach her children specifically how to survive in Crossroads, Georgia. On the one hand, she wants them to develop into strong persons; on the other hand, she wants to protect them from the evils of the world, a world that does not welcome strength from its black citizens.

Never feeling completely comfortable with the advice she bestows on her children, Laurie Lee questions every action she takes with them. One day, Robby is brought home by one of the Youngbloods' neighbors, Mrs. Sarah Wilson, because he has been fighting with white boys. When Mrs. Wilson informs Laurie Lee about the dispute and urges Laurie Lee to punish Robby, Laurie Lee responds, "I can't help what you say, Sarah Wilson. I'm never going to tell my children white folks better than they are, cause it's a lie, and I know it and—and By God, you know it too."[3] But Mrs. Wilson's only remark is, "Ain't no good coming of it, Laurie Lee Youngblood. Lord in Heaven knows it ain't."[4]

And while Laurie Lee does not readily embrace this belief, she cannot suppress the feelings of insecurity that begin to plague her:

> Maybe she was leading her children in the wrong direction—Not teaching them how to live in white folk's country—Blinding her children to the facts of life. Be polite around white folks now—Stay in your place—Take off your hat and smile when they want you to—Doesn't hurt anything—White folks aren't so bad—A colored man just got to know how to act around them. Big Mama used to say, don't ever grin in a white man's face and don't cry either. But who was right and what you going to teach your children?

Even Joe doesn't know what to advise his wife: "It ain't easy, Laurie Lee. Ain't easy atall. It's hard to say which is the right road to follow. Lord know it is. Get the short end of the stick either way the wind blows."[5]

Without her children, Laurie Lee could afford to be a revolutionary, but when she has innocent beings to protect and to nurture, she cannot be as zealous in her actions as she is naturally wont to be. With this realization, Laurie Lee begins to assuage the revolutionary spirit. She doesn't dismiss it; she simply alters her method. Evolution supplants revolution, to a certain extent. Laurie Lee again confronts this internal debate between revolution and evolution when she is called downtown to the city jail after Robby is incarcerated for fighting white boys, this time in an attempt to protect Jenny Lee.

At the jail, Laurie Lee is instructed to whip Robby in the presence of white policemen. When she asks if she can take her son home and punish him there, the authorities deny her request. And as she continues to beg for their indulgence, she is embarrassed for Robby "to hear her pleading to white folks like [that]. Like getting on her knees, like stripping buck naked in Jeff Davis Square."[6]Nonetheless, she continues to beg, only to be told that she must follow the original orders of the deputy. To save her child from the reformatory, Laurie Lee must subdue her penchant for rebellion and acquiesce to the wishes of the power structure. And to add insult to injury, the policemen sit back, smoke cigars, and behold with pleasure the entertaining spectacle. Laurie Lee is stripped of her pride just as she strips the skin off of Robby's back.

And later when she tries to explain to Robby and Jenny Lee why she was forced to whip Robby, she has difficulty fashioning the words to convey meaning, especially since she is not sure of meaning anymore. However, she does muster the courage to say, "[The white folks] got the world in their hip pockets and they aim to keep it that way. They gon keep the colored man under their feet as long as we let them. And they aren't going to stand for us fighting back fair and square."[7] And, indeed, if the fight had been fair, Laurie Lee could have

employed her usual tactics of revolution. But because she is disadvantaged, she must restructure her methods of attack, circumventing the direct approach and relying upon a strange brand of irony. Even though she physically abuses her son, she is, in fact, protecting him from a fate worse than death itself.

For Robby, this lesson is a difficult one to comprehend. Although Laurie Lee provides the best possible explanation for her action, Robby still asks, "But—did I do wrong?"[8] to which Laurie Lee responds, "It isn't a matter of right or wrong. It's just that"[9] Because Robby is still a child, he believes that there exists a moral standard of right and wrong that should not be compromised, according to his Christian upbringing. Unfortunately, that same society which upholds this moral absolute does not really intend for the black race to benefit from it; they must acknowledge it, even live by it to a certain extent, but they cannot be protected by it. When Laurie Lee says that it is not a matter of right or wrong, she is trying to tell Robby that life is not always divisible into such clear-cut categories of good/bad, right/wrong. When she tells him this, she is in fact altering her own revolutionary tendencies. We are sure that she would like to tell him that, "yes, there is easily recognizable evil in the world, and, yes, you do have a right and an obligation to obliterate it wherever you find it."

But Laurie Lee cannot tell a lie. When she instructs Robby on the realities of the world, she plants the seed for his gradual (evolutionary) maturity. His spirited streak will provide him strength, and his new knowledge of the world will provide him with the practical wisdom for surmounting the obstacles placed before him.

In spite of this advantage, Robby's transformation is not made easily. As he begins to understand some brutal truths, he must first remove the cloak of illusion that has so far protected him. As the narrator tells us, "Nothing made sense to him anymore, especially his mother. He felt like he had been put out of doors, thrown out into life on his own, no help, no guidance. Go for yourself. Nobody loves you— Nobody gives a good goddamn."[10] Before Robby can gain a more objective view of the world, he must first negate all that he has known

before. In fact, he goes from one zealous extreme to another. He cannot yet accept life's inconsistencies, for he wants everything clearly definable. In a final comment to his mother on this matter, he yells, "I don't like white people. Hate every one of them. See every last one of them in hell on the chain gang!"[11]

The one person who is able to restore Robby's faith in humanity is Richard Wendell Myles, the young school teacher from the North. After Robby's unfortunate encounter with the law, the frustrated boy—so confused that he does not know whom to trust—runs away from home and finds himself in the care of Mr. Myles. After Myles feeds him and comforts him, Robby is willing to listen to the teacher's words of wisdom. Myles states, "Your mother is wonderful. A tremendous woman.... It's an absolute fact. You know that better than anyone else. She's everything you said she was and more besides . . . She's still a great fighter."[12] Robby needs to know that his mother is still the woman whom he has for so long honored and respected. In fact, Laurie Lee's love is the only absolute that Robby can count on. And it is on that sturdy foundation that he can rebuild his faith in life, commitment, and struggle. And when Myles declares Laurie Lee a fighter, he redefines "fighting." To fight is not necessarily to revolt; sometimes it is to survive and to grow, especially when there are counteractive forces that want to impede both growth and survival.

That Mr. Myles should be the link between Laurie Lee's former revolutionary spirit and Robby's emerging evolutionary ideal is significant. Myles himself is a radical to some degree, because he is a transplanted Northerner who has yet to become completely acclimated to the Southern way of life. Initially, he does not know how to respond to his white employers: "Richard Myles looked them straight in the face, his eyes wide and arrogant, wondering what was expected of him. Should he hold out his hands and say glad to meet you? . . . He wanted to return their smiles, start off on the right foot, but he just couldn't make his face cooperate"[13]; feeling somewhat uncomfortable in the presence of these men, Myles "looked brazenly into the white man's face, his arrogant eyes deliberately widening."[14] In the North, Myles

has been used to interacting with people on a fairly equal footing, but here in Crossroads, GA, he is confronted with blatant racism and discrimination, so he does not know how to react.

Soon realizing that his attack against the Southern Code will have to be subtle and gradual, Myles focuses solely on his pupils, whose eagerness and enthusiasm impel him to enlighten them as comprehensively as he can. Myles undertakes to change the Jubilee ceremony, an annual celebration during which the black youth sing spirituals for the mostly white community. Because the children are frustrated with having to perform as though they were animals, Myles alters the entire program. Instead of simply singing, the children also provide a brief history of the true meaning of the spirituals. By interpreting the songs, they instill a sense of pride in the black community, and they undermine the feeling of inferiority that the white community has for so long invoked in the blacks.

The powerful feelings and self-esteem that this Jubilee brings about prepares Robby Youngblood for the future, when he tries to organize a union for his fellow hotel workers. Robby now knows that there are many ways to engage in battle; consequently, he employs what for him is the most productive—collective aggression. This unity involves not only the blacks of Crossroads, but also the poor whites. Unifying these two bodies, however, does not come easily, because they fear and distrust each other, a condition manifested and perpetuated by the affluent whites. If the Southern Code, with its well-defined caste system, is to be thwarted, such change will come only with both blacks and poor whites joining forces.

That such an undertaking is possible is indicated in the depiction of Oscar Jefferson, a white blue-collar worker who treats blacks with dignity. Oscar interacts with the blacks because he knows he is no better than they are; he is not blinded by the prejudice of his less perceptive counterparts. Coming to terms one day with his plight,

> [h]e stared into some of their lean hungry faces, and he was
> one of them and he knew he was one of them, and he

always had been and he couldn't get away from it. He looked about him as he walked up the street, stared into the faces of the poor white trash.... White trash white trash—he hated the word, but it was true—it was true—it was the gospel truth. He had worked almost ever since he came in the world, but he was still white trash, and niggers were niggers—Negroes were Negroes—

Understanding that his destiny is tied to that of blacks, Oscar responds to them on a human level, as evidenced in his determination to aid a dying Joe Youngblood when the victimized black man is shot down while trying to secure his accurate pay from a dishonest paymaster. Oscar, now described as "a grown man . . . and a man who had grown," completes a cycle begun with Laurie Lee and Joe Youngblood. Realizing that social change does not come about without real sacrifice, Oscar risks not only his own life, but also the life of his son, Junior. But in taking this "radical" step, Oscar simply establishes the precedent whereby others like him can begin to forego their prejudices and relate to others on a human level.

Oscar's gesture reaffirms our faith in humanity, and it also resolves somewhat the thematic conflict between revolution and evolution. The violence that eventually causes Joe Youngblood's death is, of course, the result of Joe's rebellion, or revolt. Moreover, Oscar's attitude toward blacks is the result of many years of self-reflection and observation of the world around him. Achieving his present perspective has been an evolutionary process. Both processes (evolutionary and revolutionary) are necessary if positive changes are to ensue. Killens clearly indicates that the long evolutionary cycle of life must be punctuated by isolated moments of revolution. The key to successful change, however, is knowing when to punctuate and what tools to employ.

NOTES

[1]John Oliver Killens, *Youngblood* (New York: Dial Press, 1954; rpt. Athens: Univ. of Georgia Press, 1982), 9.

[2]Killens, 10.

[3]Killens, 58.

[4]Killens, 58.

[5]Killens, 61.

[6]Killens, 170.

[7]Killens, 180.

[8]Killens, 180.

[9]Killens, 180.

[10]Killens, 181.

[11]Killens, 181.

[12]Killens, 197.

[13]Killens, 151.

[14]Killens, 152.

INDEX

African-American history 124

America 7

anachrony 54, 55, 59

analepsis 63n

L'année dernière á Marienbad 54, 61

anomie 22

auteur principle 78, 79, 81n

Baudrillard, Jean 7-8, 10-12

Bazin, Andre 78

Beresford, Bruce 78

Brault, Michél 75, 76,77

Brecht, Bertoldt 14

British character 4, 60

British colonialism 53, 61

Bureau de Film du Quebec 76

Cahiers du cinema 78

Canadian cinema 73, 79, 80

Canary Islands 2, 4, 65-71

chaos theory 42

Children of Sanchez 84

class conflict 109, 111, 114, 117

DeLacroix, René 74

democracia que viene, La 88

De Palma, Brian 23

de Tocqueville, Alexis 8

Devlin, Bérnard 75

dianoia 43

Didion, Joan 107

direct cinema 76, 81n

Dr. Jekyll and Mr. Hyde 2, 3, 37-52

Eco, Umberto 41

Edgar, Brian 2, 93-108

Entrada libre 84

evil, nature of 38, 45, 46, 47, 48-50

evolution 41, 44, 45, 47, 48, 49, 123-124, 127-129, 131

Expressionism in theatre 40

fabula 62n

Falangists 67

fascism 69

female spectator 2, 109-121

feminist criticism 109, 111, 112, 117

fetishism 110, 112, 119, 119n, 120n

flashback 54, 56, 58

flashforward 54

Ford, John 23

Franco, Francisco 66, 67

Freudianism 46, 109, 110, 111

gaze 110, 112, 117

Genette, Gerard 54, 56, 59, 63n

Gothic novel 40

Grierson, John 74

Groulx, Gilles 75, 77

Hare, David 4, 53-63

Hemingway, Ernest 2, 93-108

Herrman, Bernard 22, 23, 30

Hiroshima mon amour 54, 56

histoire (story) 54, 57, 59

Hitchcock, Alfred 3, 21-35, 109-121

Himmel über Berlin, Der 19

horror genre 43, 44

"Indian Camp" 2, 93-108

Infinite War, The 4, 65-71

In Our Time 95, 105

Jim Crow 4, 123, 125

Jutra, Claude 75, 77, 78

Killens, John Oliver 4, 123-132

Lacan, Jacques 109, 110

León Barreto, Luis 4, 65-71

Lewis, Oscar 84

McMurtry, Larry 9

Monsiváis, Carlos 4, 84-92

montage 54, 57, 59, 61

mythic narratives 37, 39-40, 42

Nada, Nadie 85, 91

narrative cinema 110

National Film Board (Canada) 74, 80

Native Americans 2, 96, 100, 101, 103

NeoGothicism 40, 43

New Wave Movement 78, 79

Ortiz Pinchitti, José Agustin 88, 90

paralipsis 59

Paris, Texas 3, 7-20,

Partido Revolucionario Institucional (PRI) 87, 89, 90

Paz, Octavio 87, 90

Peeping Tom 28, 32

Poniatowska, Elena 4, 84-92

Powell, Michael 28, 32

Psycho 25, 29, 32

psychoanalysis 109, 110, 111, 112, 119, 120n

Quebec cinema 3, 73-82

québecois culture 3, 73-82

"Quiet Revolution, The" 76-77

Rear Window 4, 25, 32, 109-121

récit (narrative) 54, 59

recycling of narratives 38, 44

Resnais, Alain 54, 56, 61

revolution 4, 123-124, 128-129, 131

science and society 38, 43, 44-45, 47, 48, 49

science fiction 40

Scorsese, Martin, 3, 21-35

Schrader, Paul 23

Searchers, The 23

Shepard, Sam 9

Southern Code 123, 125, 130

Spanish Civil War 65-71

Stevenson, Robert Louis 3, 37-52

syuzhet 62n

Taxi Driver 3, 21-35

testimonial narrative 4, 84

Texas 7, 9, 14-15

Texasville 9, 18

"Three Shots" 98, 105

"tracer text" 37, 38, 41, 47-48

Truffaut, Francois 78

Verfremdungseffect 9, 14

Vertigo 3, 21-35

Victorian era 40, 41, 43

violence 46, 47, 48, 49

voyeurism 4, 25, 28, 30, 110, 111,
112, 119

Wenders, Wim 3, 7-20
Wetherby 4, 53-63

Youngblood 4, 123-132